VINTAGE COCKTAILS

© 2009 Assouline Publishing
601 West 26th Street, 18th floor
New York, NY 10001, USA
Tel.: 212 989-6810 Fax: 212 647-0005
www.assouline.com
ISBN: 978 2 7594 0413 1
10 9 8 7 6 5 4 3 2
Printed in China.
No part of this book may be reproduced in any form
without prior permission from the publisher.

Design by Camille Dubois. The photographs of the cocktails
featured in this book were shot at Bemelmans Bar in The Carlyle, New York.
All photographs © Laziz Hamani, except page 7: © Slim Aarons/Getty Images.

VINTAGE COCKTAILS

PHOTOGRAPHS BY LAZIZ HAMANI

INTRODUCTION BY BRIAN VAN FLANDERN

ASSOULINE

Introduction

The word *vintage* often implies antique, a relic from the past that has come back into vogue. Not to be confused with the classic cocktail, the vintage cocktail conjures images of specific places in time when a particular cocktail gained global popularity. Many of the recipes featured in this book survived the devastating years of Prohibition (1920–1933), while others, like the Brandy Crusta (created in New Orleans in 1852), boast legacies of over a century.

The history of each cocktail is rich and varied. Some were created outside of the United States prior to Prohibition, when being a barman was a respectable profession. The Sidecar, for example, was first created during World War I in Paris, when an American soldier ordered the drink and it was served aboard the sidecar of his motorcycle. The Singapore Sling was first mixed in 1915 halfway around the world in the now famous Raffles Hotel bar in Singapore by barman Ngiam Tong Boon.

Even during and after prohibition, vintage cocktails were inspired by local ingredients and the politics of the day. The Hemingway Daiquiri was created in 1921 for Ernest Hemingway, who escaped to Cuba to drink them on a regular basis. The famous Piña Colada is often credited to Ramon "Monchito" Marrero Perez in 1954 at the Caribe Hilton in San Juan, Puerto Rico.

The word *cocktail* itself just passed its two-hundredth anniversary in 2006 and in celebration, many bartenders revived the pre-Prohibition recipes and recreated them

for their modern guests. Using fresh ingredients and quality spirits, today's bartenders are approaching the cocktail as a culinary art form.

The recipes contained herein, all of which were photographed in The Carlyle hotel's world-famous Bemelmans Bar, are some of my favorites. I have also included a splash of twenty-first century drinks that I have designed for Bemelmans. From the superwealthy tycoon to the man on the street, the bar represents a bygone era and a real slice of New York. Half a dozen presidents and countless celebrities call The Carlyle their home when visiting Manhattan, and Bemelmans is the perfect camouflage for those who just want to blend in—or simply enjoy the perfect cocktail with a sublime ambience. Drinks like Dale DeGroff's Whiskey Smash or Audrey Saunders's Gin-Gin Mule are destined to become classics, and I think it is safe enough to classify them as vintage cocktails created in New York City.

In the end it all comes back to the drinks. The recipes that follow are tried and true. I encourage you to work your way through them and find the ones you like. When prepared well, a vintage cocktail is a thing of joy. As you step back in time, revel in the new golden age of the vintage cocktail. Until our next drink together...

Bottoms up,

Brian Van Flandern
head mixologist
Bemelmans bar at The Carlyle

Contents

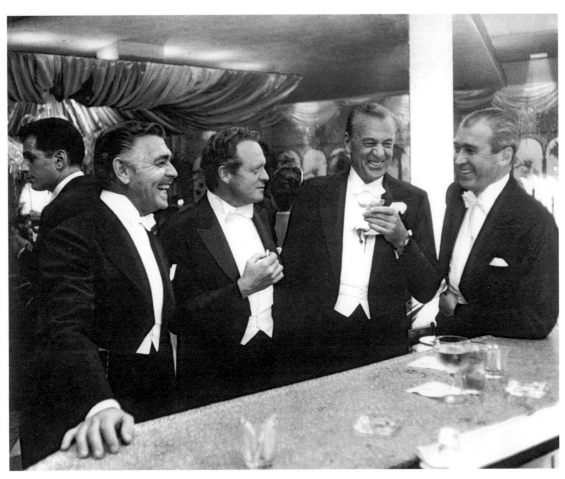

Clark Gable, Van Heflin, Gary Cooper, and James Stewart enjoy a drink and a joke
at a party held at Romanoff's in Beverly Hills, New Year's Eve 1957. Photograph by Slim Aarons.

AGAVE GINGERITA

1 1/2 oz. DON JULIO REPOSADO
100% AGAVE TEQUILA

1/4 oz. CANTON GINGER
LIQUEUR

1/4 oz. FRESH GINGER JUICE

1/2 oz. FRESH LIME JUICE

1/2 oz. AGAVE SYRUP

ONE EGG WHITE

DRY SHAKE INGREDIENTS VIGOROUSLY
AND STRAIN OVER ICE IN ROCKS GLASS
GARNISH WITH CANDIED GINGER AND SERVE.

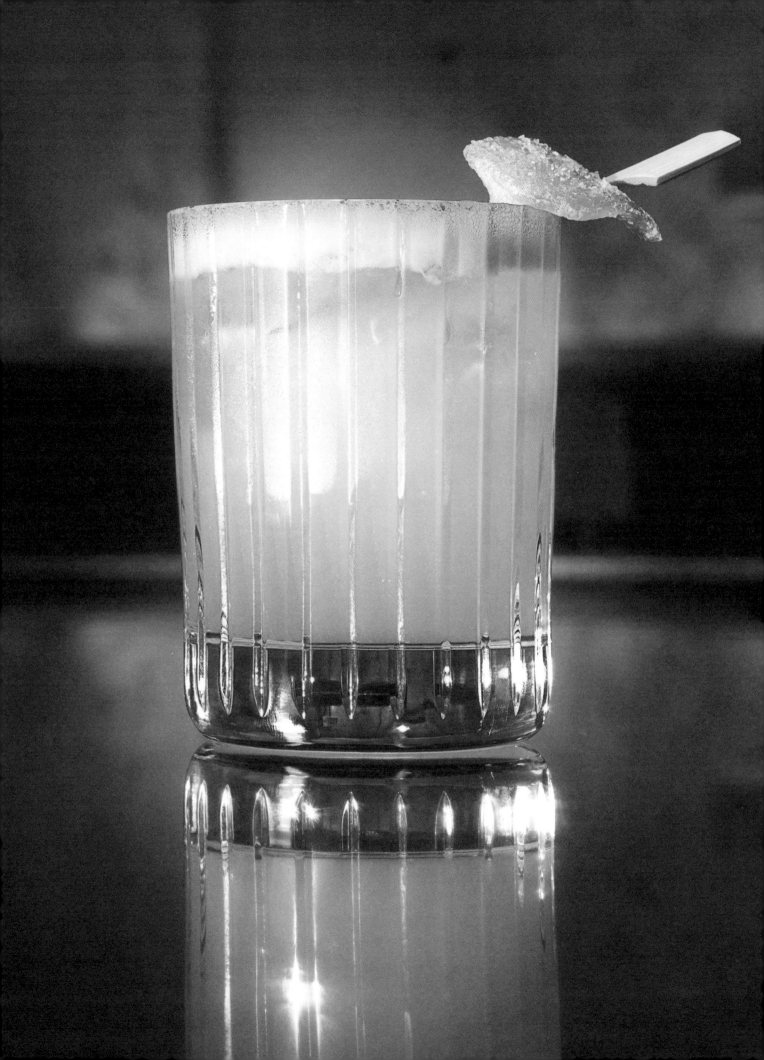

BETWEEN THE SHEETS

1 1/2 oz. V.S. Cognac

1/2 oz. Benedictine

1 l2 oz. Cointreau

3l4 oz. fresh lemon juice

Shake all ingredients with ice and strain into a chilled cocktail glass. Garnish with a burnt orange peel.

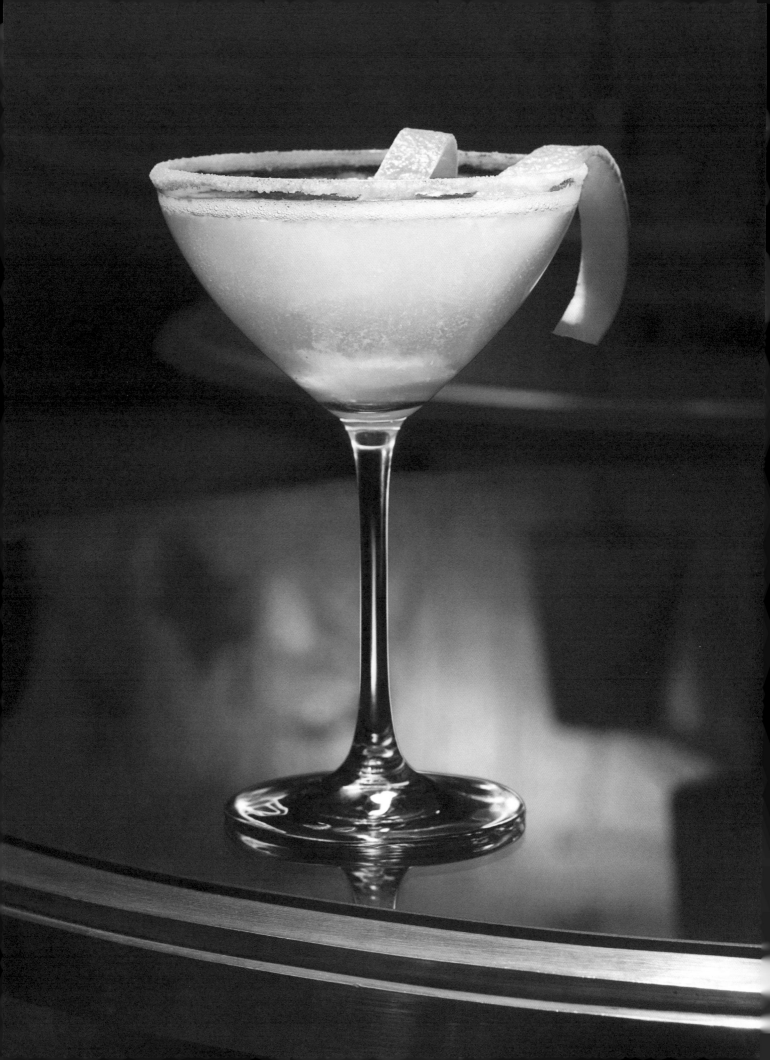

BLOODY MARY

1½ oz. Vodka

4 oz. tomato juice

2 dashes Worcestershire

4 dashes Tabasco

Pinch of salt and pepper

¼ oz. fresh lemon juice

combine all ingredients in a mixing glass and roll back and forth to mix. Strain into a highball glass. Garnish with a lime wedge and celery stalk.

A dash of celery salt is a nice touch and most bartenders traditionally add 1 tsp. of horseradish.

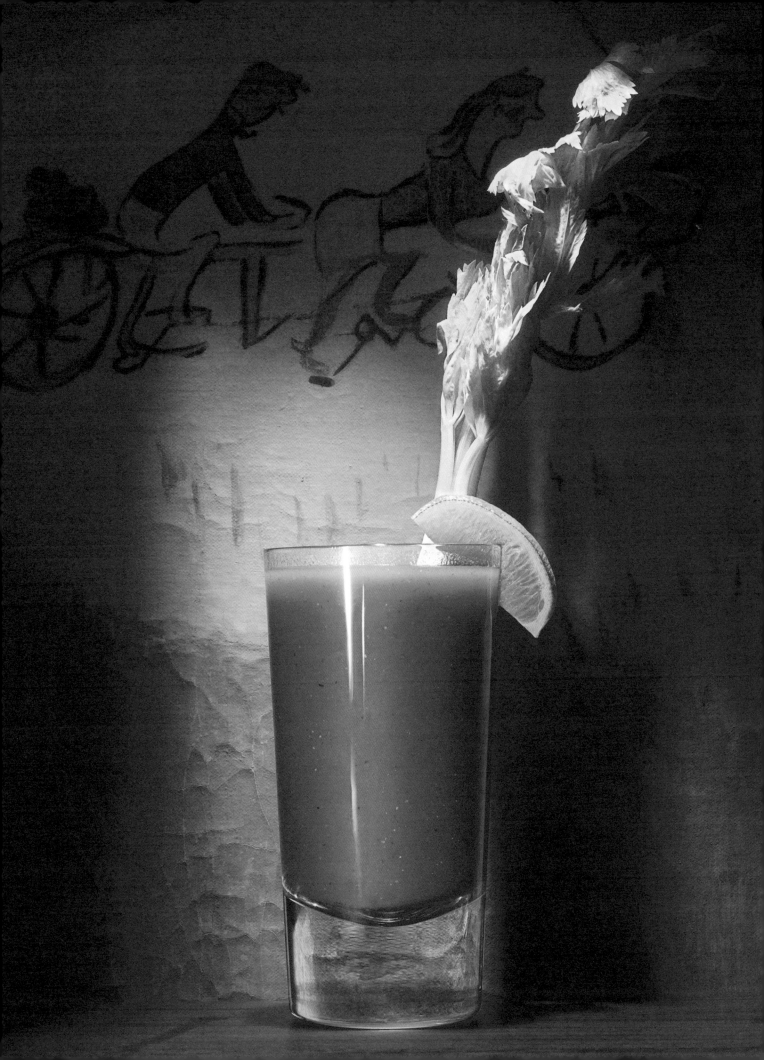

BLUE HAWAIIAN

1 1/2 oz. LIGHT RUM

3/4 oz. BLUE CURAÇAO

3/4 oz. FRESH LEMON JUICE

1 oz. SIMPLE SYRUP

2 oz. PINEAPPLE JUICE

1 PINEAPPLE WEDGE

SHAKE OR BLEND ALL INGREDIENTS WITH ICE AND STRAIN INTO A BOCA GRANDE OR OTHER TROPICAL GLASS. GARNISH WITH A PINEAPPLE SLICE AND A CHERRY.

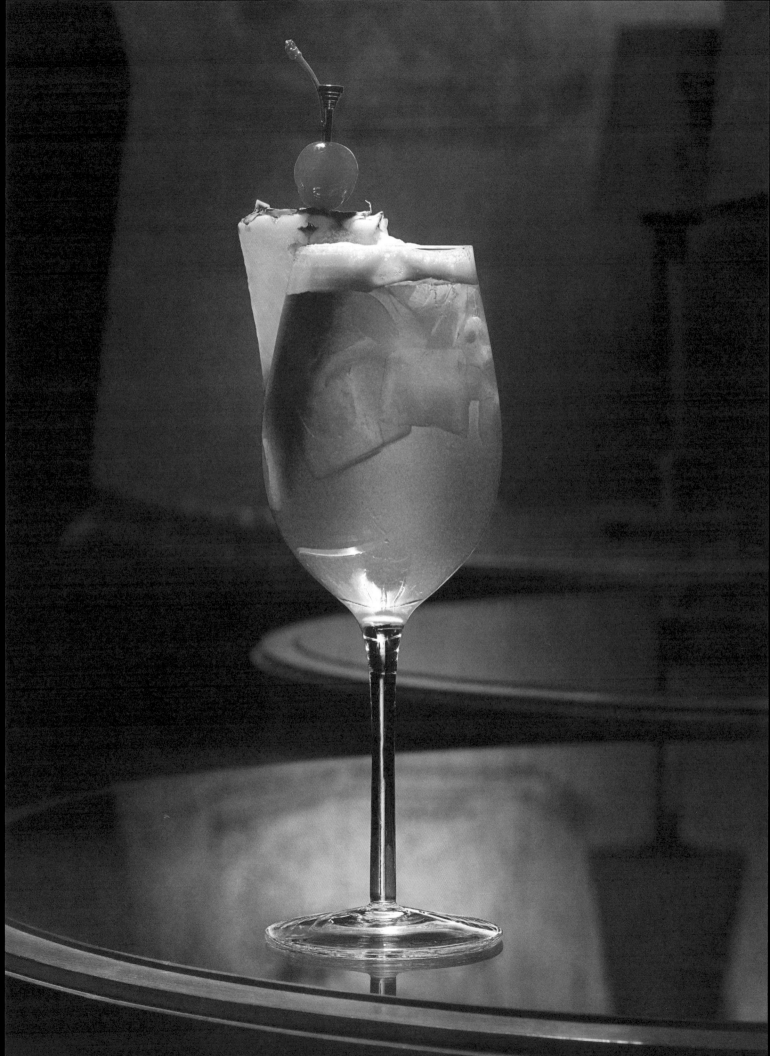

The Bradshaw

(created for The Carlyle on the occasion of the filming of scenes in the movie "Sex and the city" at Bemelmans Bar.)

2oz. Don Julio
Tequila Blanco 100% Agave Tequila

1/2 oz. Lime juice

1/2 oz. Simple Syrup

1 oz. X-Rated Passion Fruit-Infused Vodka

Shake all ingredients together vigorously with ice. Strain into a martini glass with a hot pink sugared rim. Garnish with a lime wedge and serve.

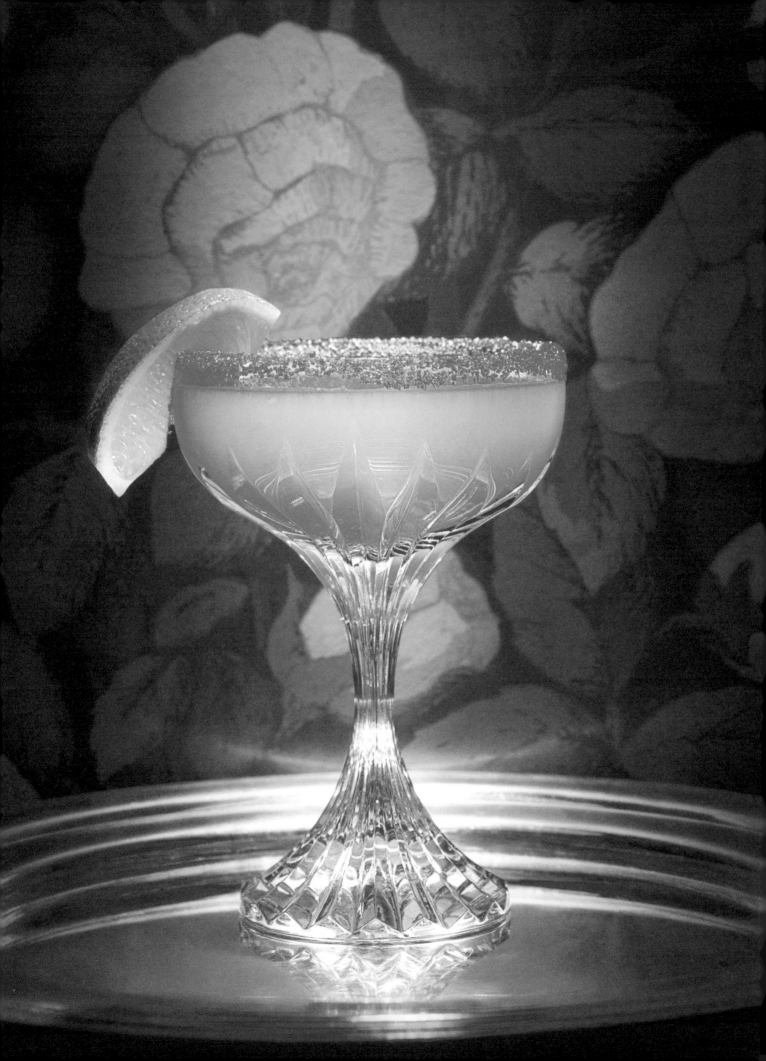

BRANDY ALEXANDER

1 1/2 oz. BRANDY

1 oz. DARK CRÈME DE CACAO

1 oz. HALF. AND. HALF

1/4 tsp. GRATED NUTMEG

In a shaker, combine the brandy, crème de cacao and half-and-half.

Add ice and shake well.

Strain into a cocktail glass and garnish with nutmeg.

BRANDY CRUSTA

1 1/2 oz. V.S. COGNAC

1/4 oz. MARASCHINO LIQUEUR

1/4 oz. ORANGE CURAÇAO

1/4 oz. FRESH LEMON JUICE

1 DASH ANGOSTURA BITTERS

Combine all ingredients in a mixing glass and shake well. Strain into a small cocktail glass with a lightly sugared rim. Garnish with small spiral of lemon around the inside rim of glass.

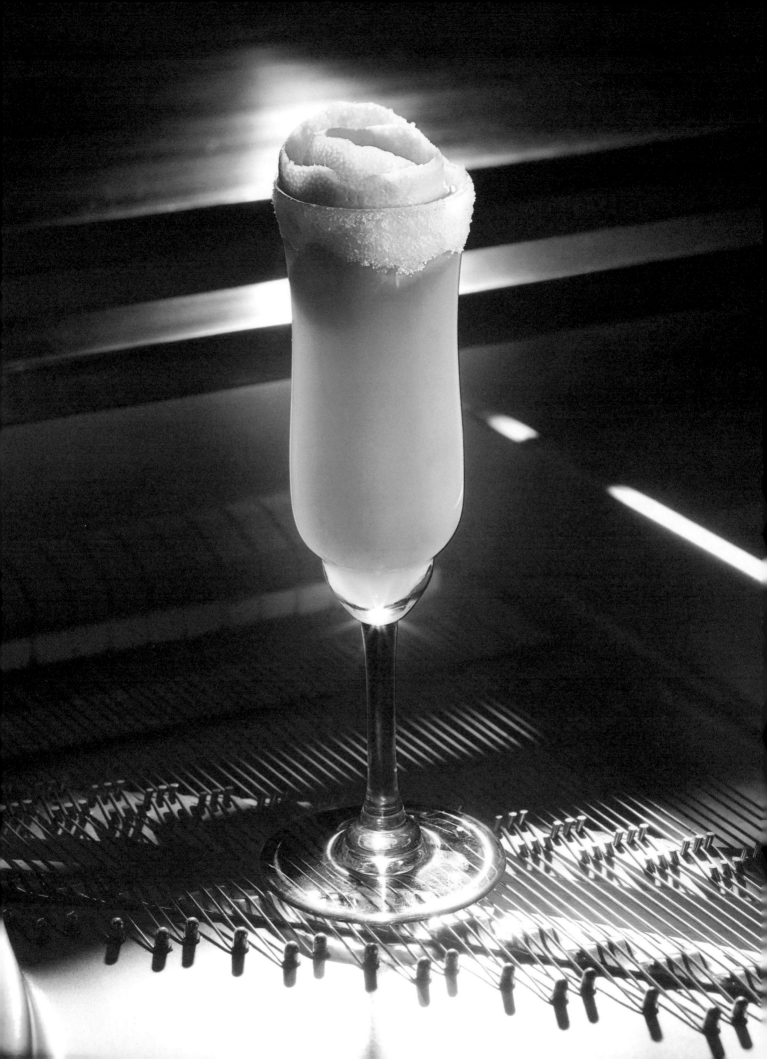

BRANDY FLIP

2 oz. BRANDY (VSOP Cognac)

1 whole egg

1 tsp. SUPERFINE SUGAR

1/2 oz. LIGHT CREAM

1/8 tsp. grated nutmeg

In a shaker, combine the brandy, egg, sugar and cream. Add ice and shake well. Strain into a cocktail glass and garnish with nutmeg.

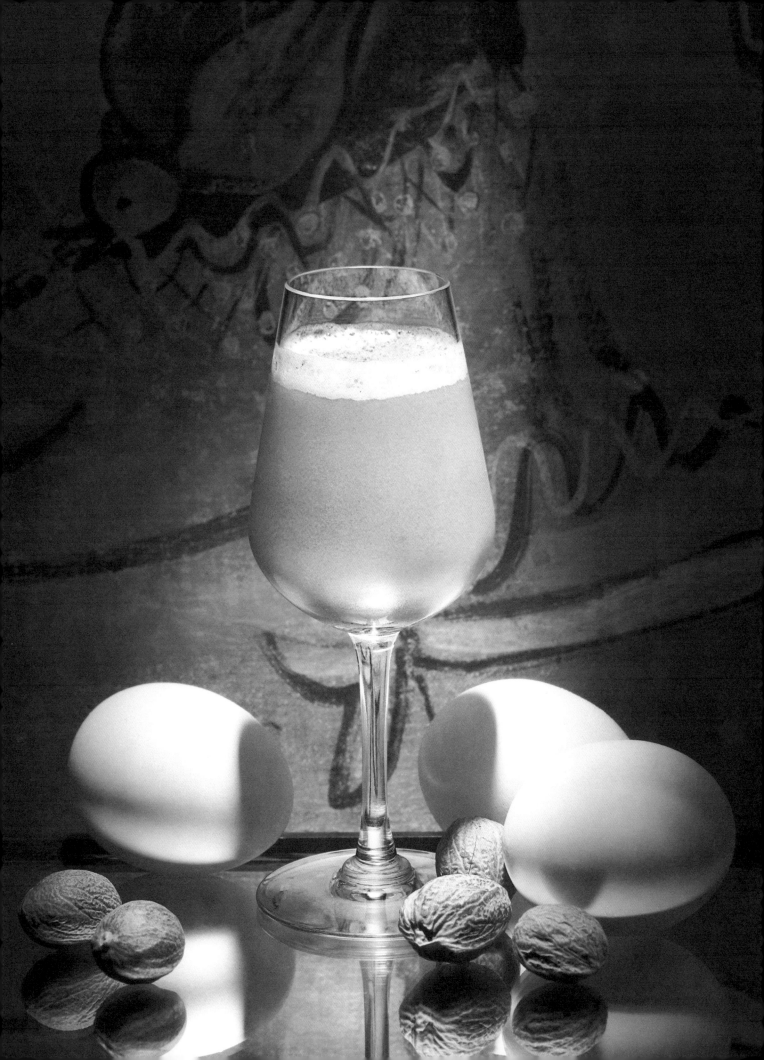

CAPE CODDER

1/2 oz. Vodka

Fresh Cranberry juice with sugar
or Ocean Spray Cranberry Juice Cocktail

Combine in a highball glass with ice.

Garnish with a lime.

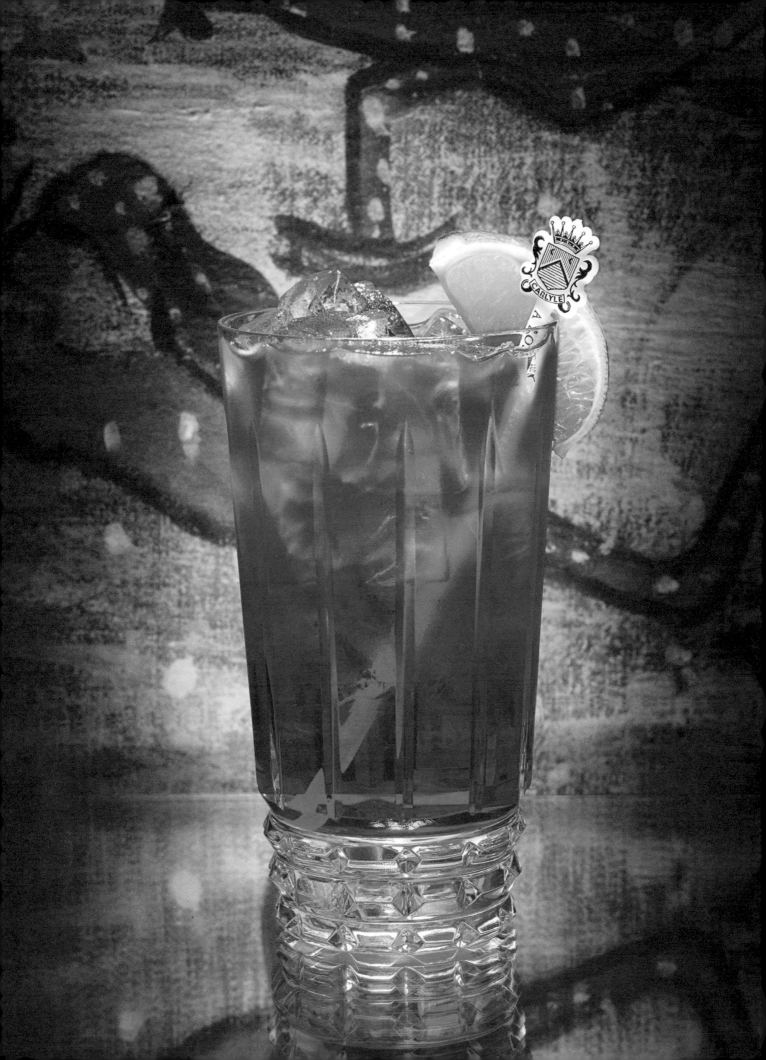

CHAMPAGNE COCKTAIL

CHAMPAGNE
ANGOSTURA BITTERS-SOAKED SUGAR CUBE

PLACE THE SMALL SUGAR CUBE IN THE BOTTOM OF A CHAMPAGNE FLUTE. ADD 2 DASHES OF ANGOSTURA BITTERS AND FILL THE GLASS WITH CHAMPAGNE. THIS DRINK IS SOMETIMES GARNISHED WITH A LEMON PEEL. FOR A STRONGER DRINK, ADD A FLOAT OF COGNAC OR GRAND MARNIER.

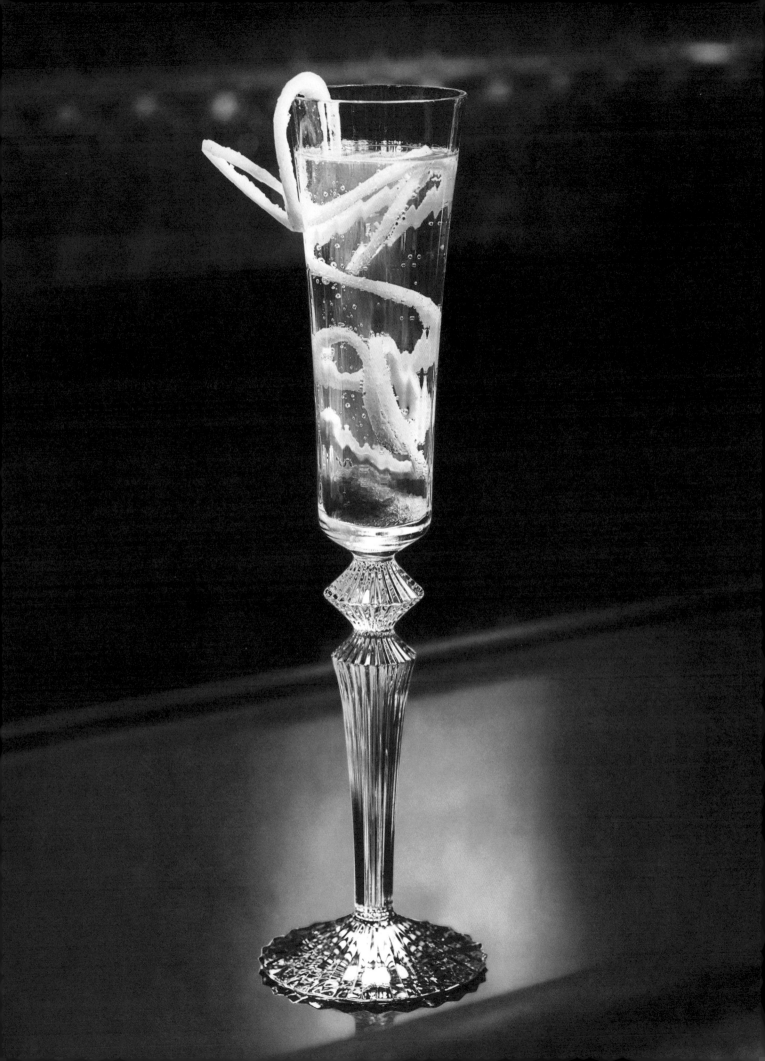

CLOVER CLUB

1 ½ oz. GIN

½ oz. SIMPLE SYRUP

3/4 oz. FRESH LEMON JUICE

2 DASHES OF RASPBERRY
SYRUP OR GRENADINE

WHITE OF A SMALL EGG

Shake all ingredients with ice and strain into a chilled cocktail glass.

Drinks with egg must be shaken harder and longer in order to emmulsify egg-

COLLINS

1 1/2 oz. gin, Bourbon or Vodka

1 oz. simple syrup

3/4 oz. lemon

fill with club soda

Shake spirit, sugar and lemon juice with ice and strain into an iced Collins glass and fill with soda. Garnish with a cherry and an orange slice.

DAIQUIRI

1 1/2 oz. LIGHT RUM
1 oz. SIMPLE SYRUP
3/4 oz. FRESH LIME JUICE

Shake all ingredients with ice and strain into a small cocktail glass filled with fresh ice.

DIRTY MARTINI

3 oz. gin or vodka

Rinse of dry french Vermouth

2 dashes olive brine

Rinse glass out with Vermouth and then stir ingredients with ice in a mixing glass. Strain into a chilled martini glass.

Garnish traditionally with a small Spanish cocktail olive.

DRY MARTINI

1 1/2 oz. DRY GIN
1 1/2 oz. DRY FRENCH
VERMOUTH

STIR ALL INGREDIENTS WITH ICE TO CHILL. GARNISH WITH AN ORANGE PEEL, LEMON PEEL OR OLIVES.

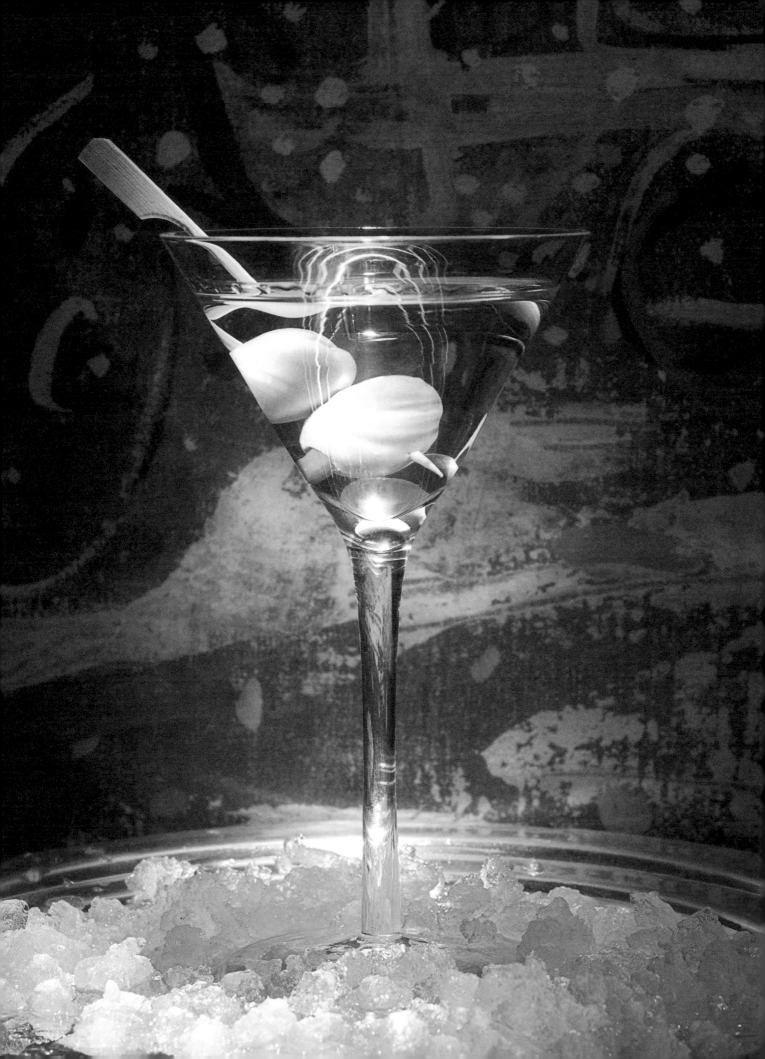

FLAME OF LOVE MARTINI

1/2 oz. FINO SHERRY
 (LA INA or TIO PEPE)
2 1/2 oz. VODKA

SEVERAL PEELS OF ORANGE

Coat the inside of a chilled martini glass with fino sherry and toss out the excess. Flame several orange peels into the glass to season.

Stir the vodka and strain into the seasoned glass. Garnish with an orange peel. Note: the gin version of this drink is called a Valencia or a Spanish Martini.

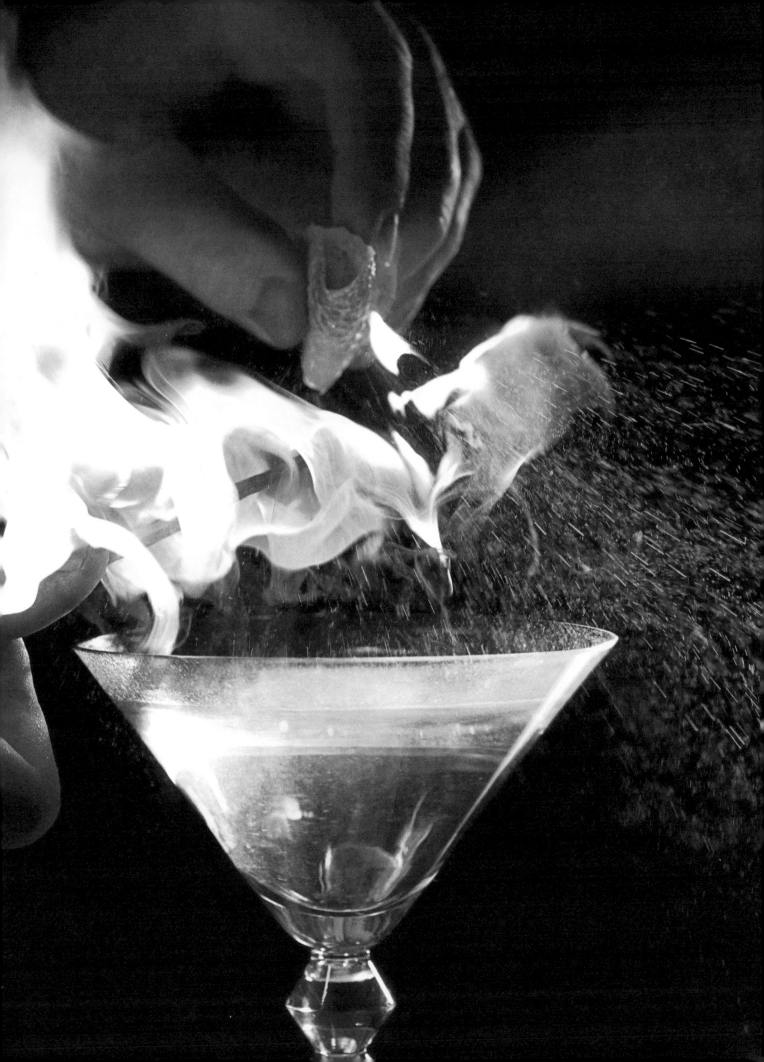

FRENCH 75

1 oz. V.S.O.P. COGNAC
1 oz. SIMPLE SYRUP
3/4 oz. FRESH LEMON JUICE

CHAMPAGNE

SHAKE THE BRANDY, LEMON JUICE AND SUGAR WITH ICE. STRAIN INTO A FLUTE AND FILL WITH CHAMPAGNE.

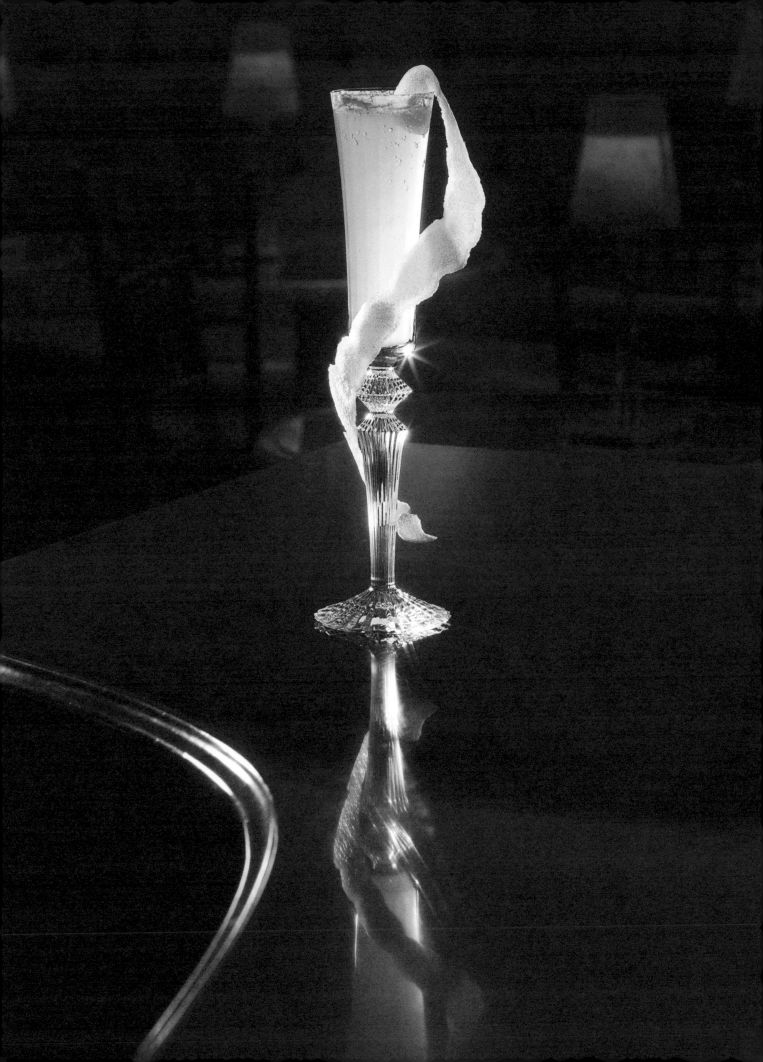

FRENCH MARTINI

1 ½ oz. VODKA

½ oz. CHAMBORD

1 ½ oz. PINEAPPLE JUICE

SHAKE ALL INGREDIENTS
WITH ICE AND STRAIN
INTO A CHILLED
MARTINI GLASS.

NO GARNISH.

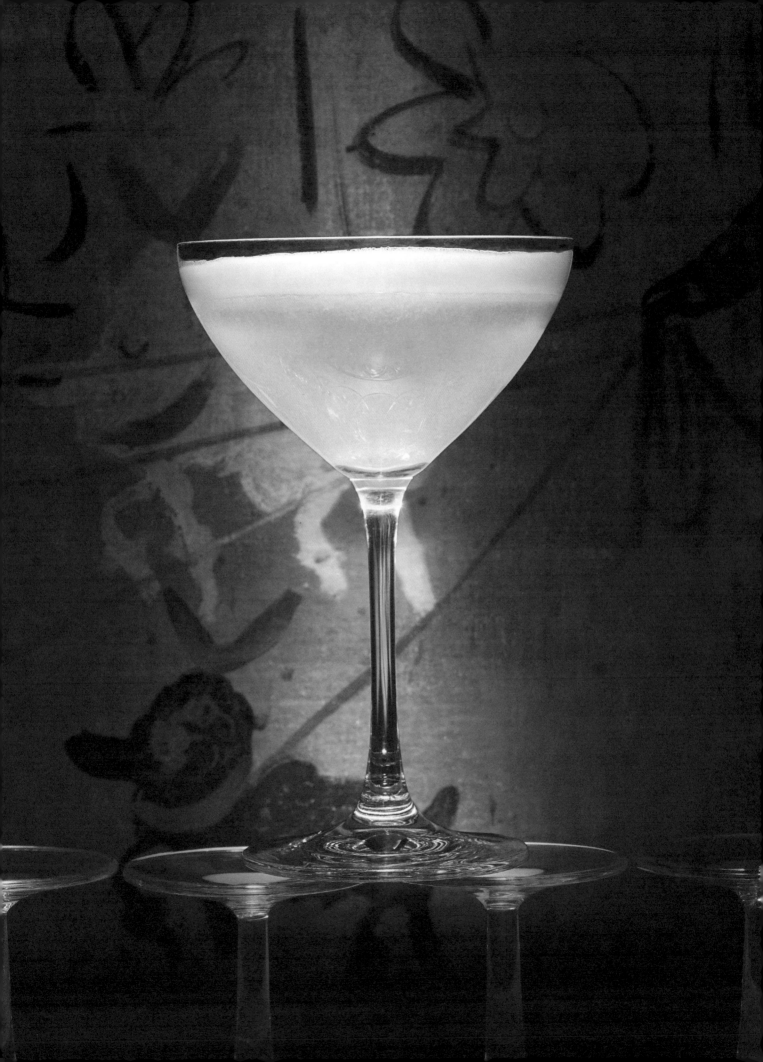

GIMLET

2 1/2 oz. GIN

3/4 oz. FRESH LIME JUICE

1 oz. SIMPLE SYRUP

shake all ingredients well with ice and strain into a chilled martini glass or serve over ice in an old fashioned glass.

Garnish with lime wedge.

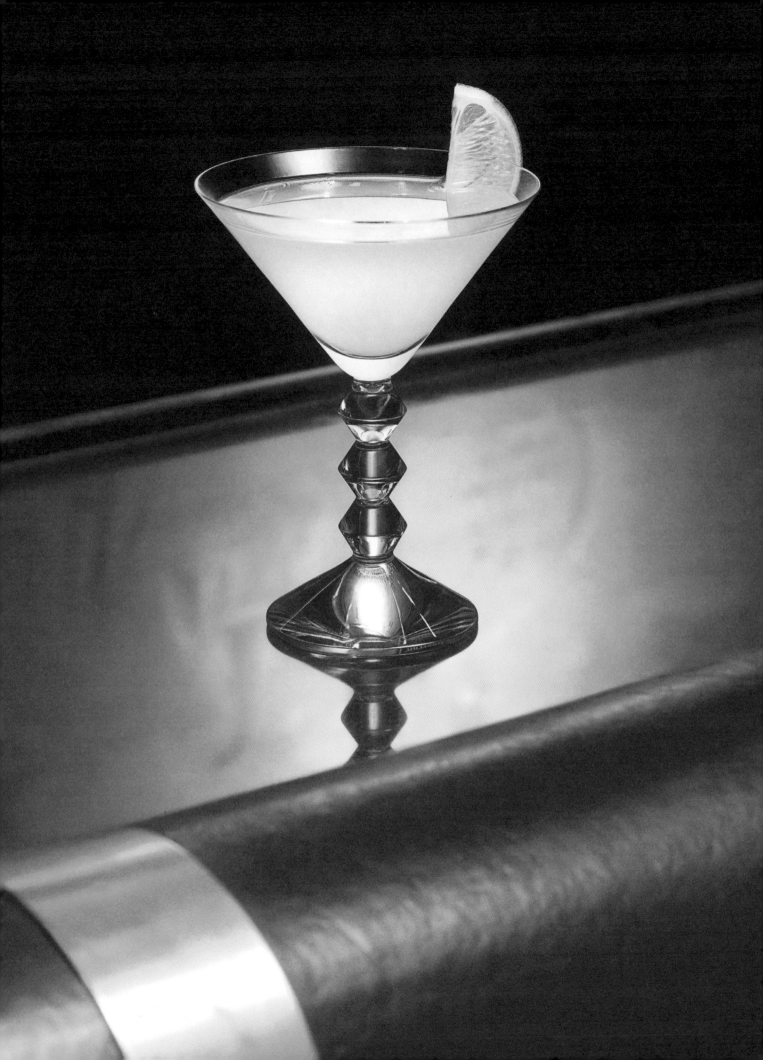

Gin Fizz

1 1/2 oz. gin

3/4 oz. fresh lemon juice

1 oz. simple syrup
(or 1 tsp. superfine sugar)

club soda

Shake and strain into a highball glass. Fill with club soda.

No garnish.

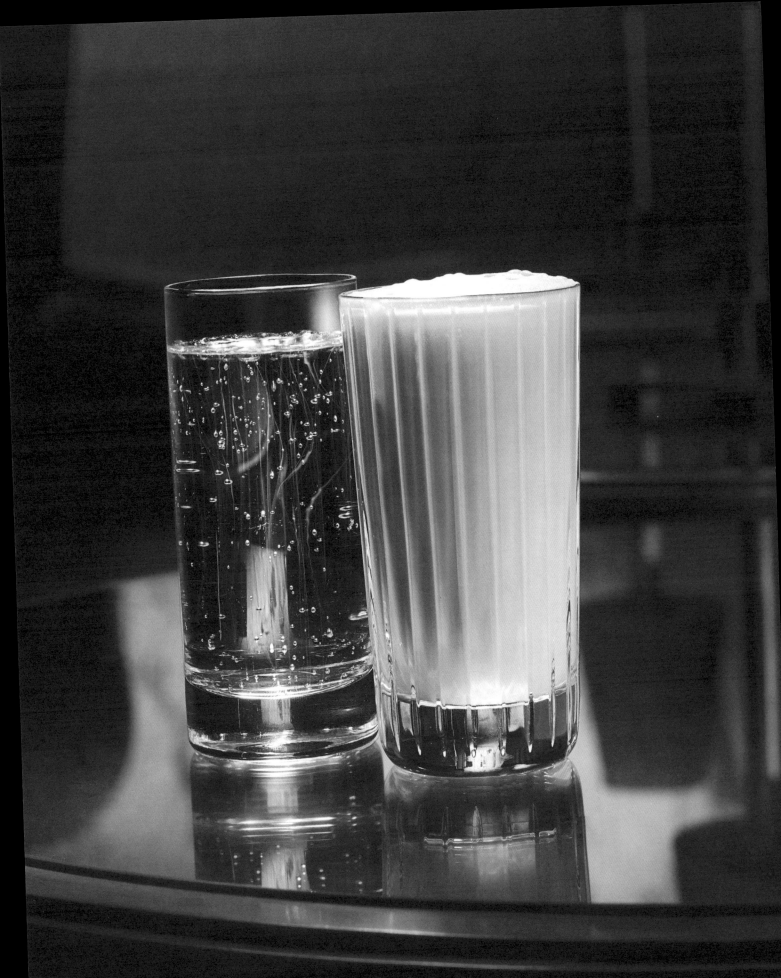

GIN-GIN MULE

CREATED FOR BEMELTANS BAR BY AUDREY SAUNDERS

1/2 OZ. LIME JUICE

1/2 OZ. SIMPLE SYRUP

6 MINT SPRIGS

3/4 OZ. HOMEMADE GINGER BEER

1/2 OZ. TANQUERAY TEN GIN

SPLASH OF SODA WATER

LIME WEDGE FOR GARNISH

Muddle lime juice, simple syrup, and mint. Add gin and shake well. Add ginger beer and tumble roll. Serve over ice in a highball glass. Top with soda and garnish with a lime wedge.

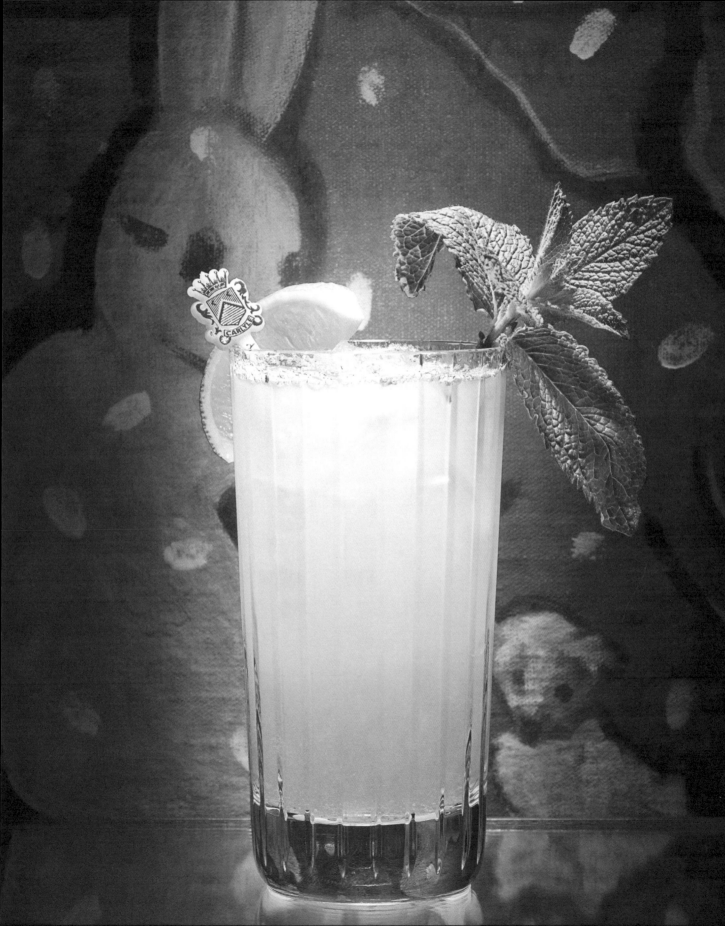

GIN SOUR

2 oz. GIN
3/4 oz. FRESH LEMON JUICE
1 oz. SIMPLE SYRUP

SHAKE INGREDIENTS AND STRAIN
INTO AN ICED COLLINS GLASS —

GARNISH WITH
AN ORANGE SLICE
AND MARASCHINO
CHERRY OR CITRUS WEDGE.

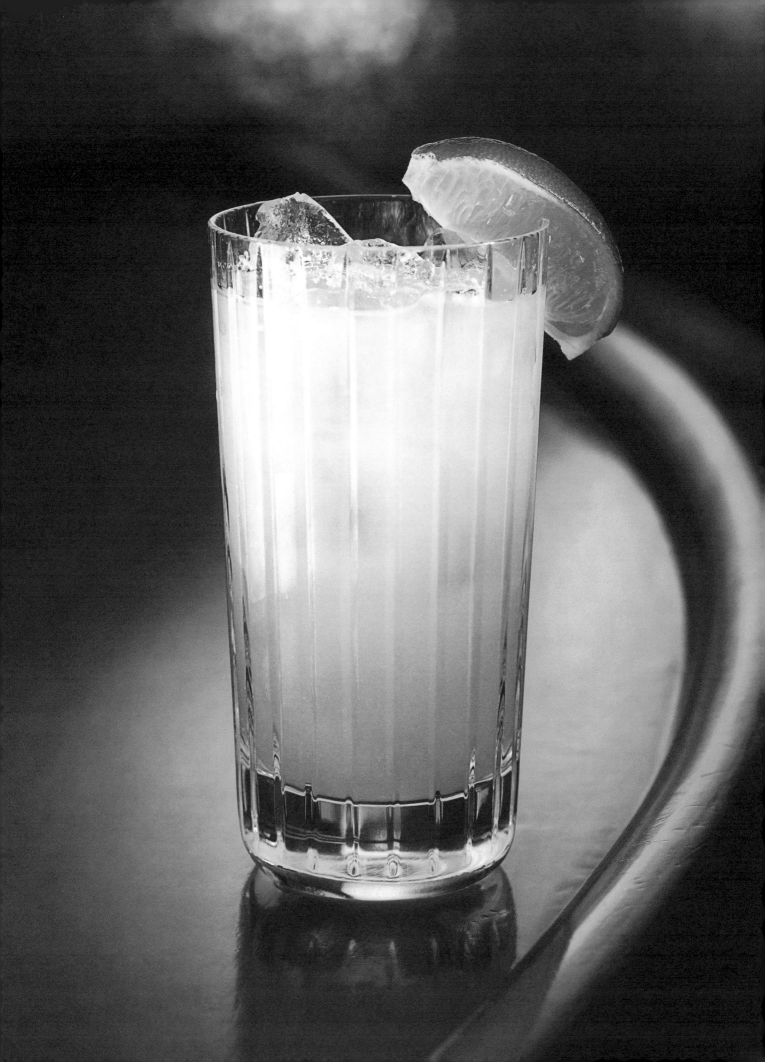

GRASSHOPPER

1 oz. CRÈME DE MENTHE
1 oz. CRÈME DE CACAO
2 oz. HEAVY CREAM

SHAKE ALL INGREDIENTS
WITH ICE, STRAIN INTO
A SMALL MARTINI GLASS.

GARNISH
WITH MINT.

GREYHOUND

1 1/2 oz. VODKA

2 1/2 oz. GRAPEFRUIT JUICE

POUR TOGETHER INTO A ROCKS GLASS.

HEMINGWAY DAIQUIRI

1 oz. WHITE RUM

1/4 oz. MARASCHINO LIQUEUR

1 1/2 oz. GRAPEFRUIT JUICE

3/4 oz. SIMPLE SYRUP

3/4 oz. FRESH LIME JUICE

SHAKE ALL INGREDIENTS
AND STRAIN
INTO A SMALL
COCKTAIL
GLASS.

HOT TODDY

2 oz. BRANDY, DARK RUM OR
SINGLE-MALT SCOTCH WHISKEY
1 tsp. HONEY OR DEMERARA SUGAR
1 LARGE PIECE OF LEMON

PREPARE A SNIFTER BY RINSING IT WITH
BOILING WATER AND POURING THE WATER
OUT. ADD THE SUGAR OR HONEY AND
THE LEMON PEEL. POUR IN AN OUNCE OF
HOT WATER AND STIR UNTIL THE
SWEETENER HAS DISSOLVED. ADD THE SPIRITS
AND TOP OFF WITH ANOTHER OUNCE OR TWO OF
BOILING WATER. STIR AND GARNISH.

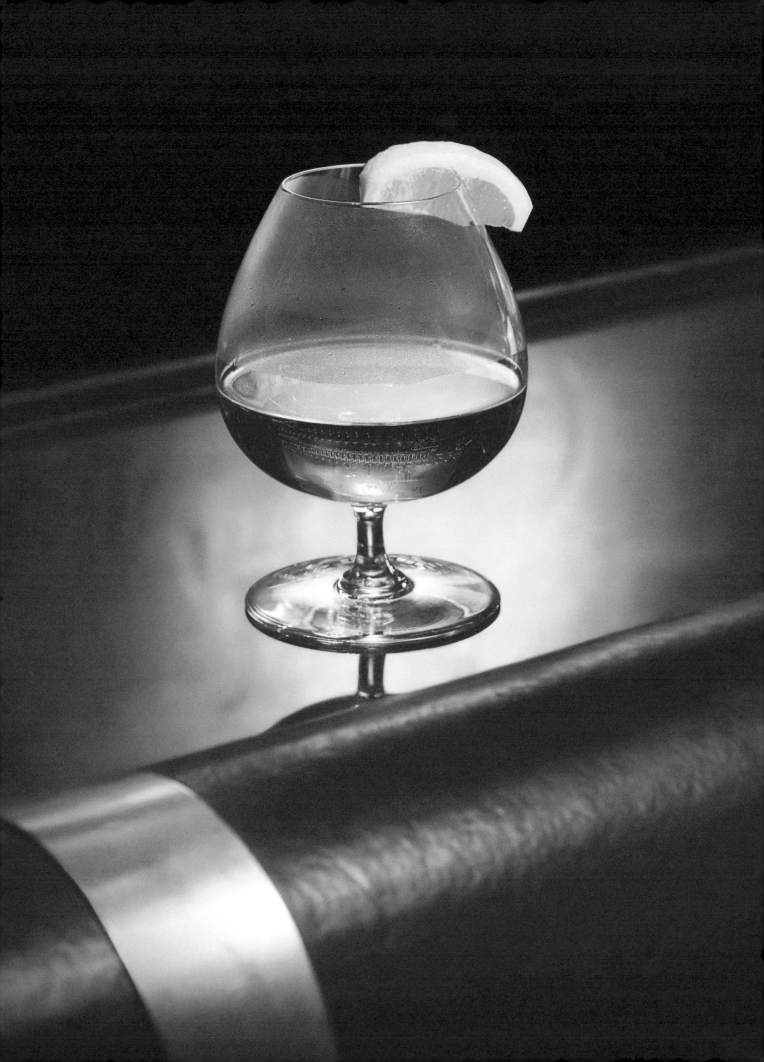

IRISH COFFEE

1 1/2 oz. Irish Whiskey

1 oz brown sugar syrup

4 oz. coffee

top with lightly whipped
unsweetened cream

Combine Whiskey coffee and syrup in an Irish coffee glass

Ladle one inch of cream on top.

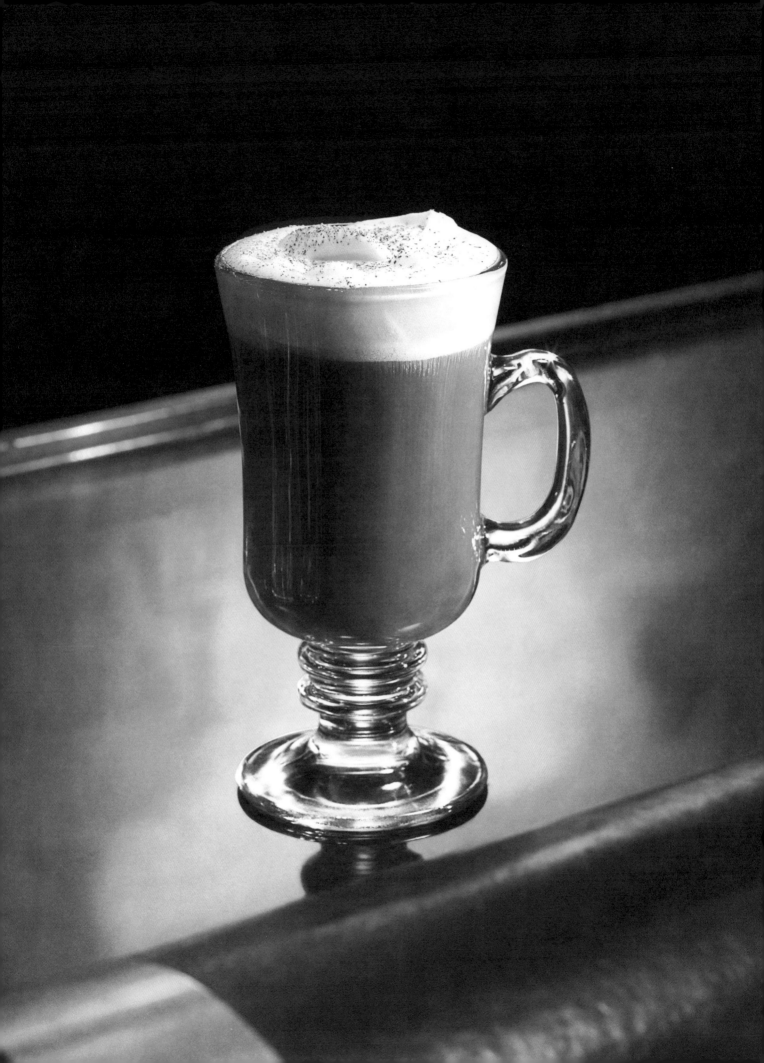

MAI TAI

2 oz. aged rum
3/4 oz. orange curaçao
3/4 oz. lime juice
1/2 oz. orgeat syrup

Shake well with ice and strain
into an old fashioned glass
filled with ice.
Garnish with a vandal orchid
or mint and a wedge of lime.

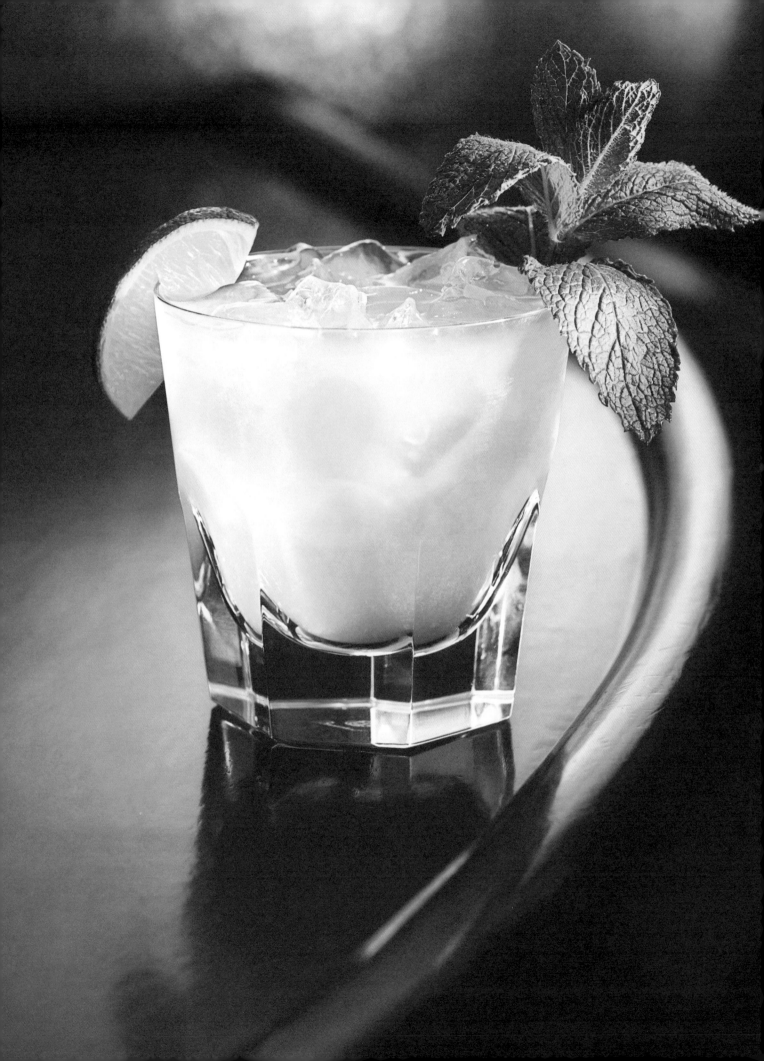

MANHATTAN

2 oz. WHISKEY
1 oz. SWEET ITALIAN VERMOUTH
2 DASHES ANGOSTURA BITTERS

Pour all ingredients over ice in a mixing glass and stir as you would a MARTINI.
Strain into a chilled cocktail glass. Garnish with a cherry (or twist if using dry Vermouth).

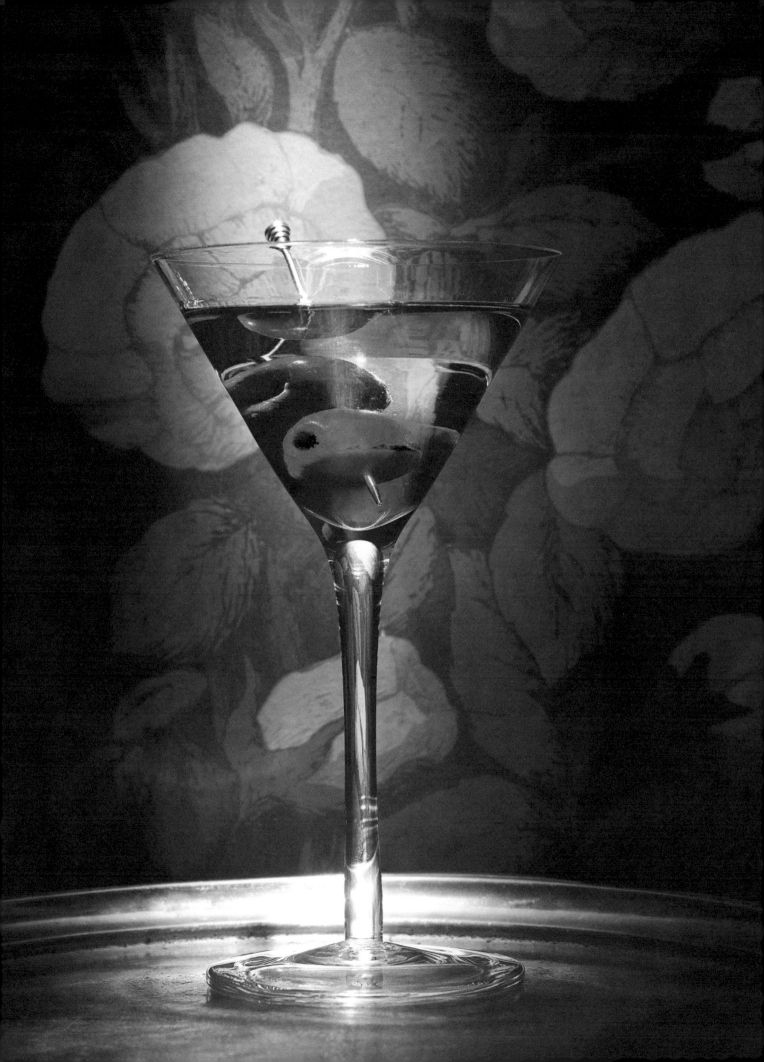

MARGARITA

2 oz. DON JULIO 100% BLUE AGAVE BLANCO TEQUILA

1 oz. COINTREAU (OR GRAND MARNIER)

3/4 oz. FRESH LIME JUICE

1/2 oz. OF SIMPLE SYRUP IS OPTIONAL BUT OFTEN NECESSARY FOR MANY GUESTS

GARNISH WITH LIME WEDGE
COARSE SALT

Combine first three ingredients in a mixing glass with ice. Shake well and strain into a chilled cocktail glass. Salting the rim: Frost the edge of the cocktail glass by rubbing a lime wedge on the outside rim of the glass, then dipping it into a saucer of coarse salt.

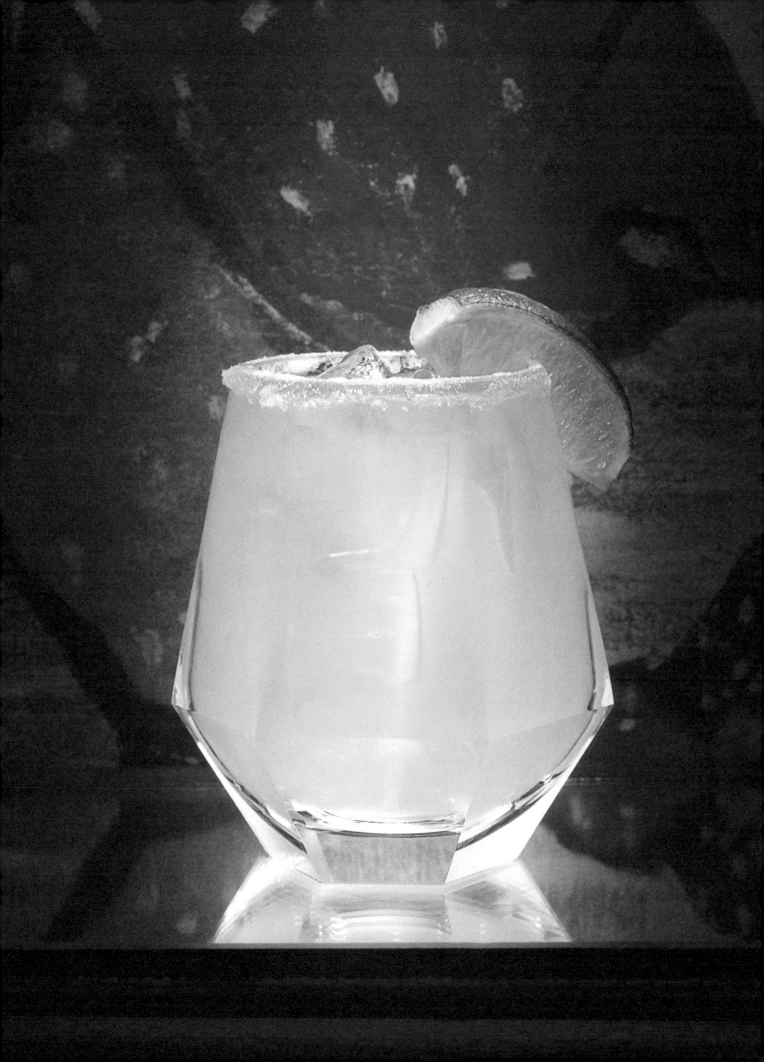

MARY PICKFORD

2 oz. WHITE RUM

1½ oz. PINEAPPLE JUICE

1 tsp. GRENADINE

¼ oz. MARASCHINO LIQUEUR

SHAKE WITH ICE
AND STRAIN
INTO A
CHILLED
MARTINI GLASS.

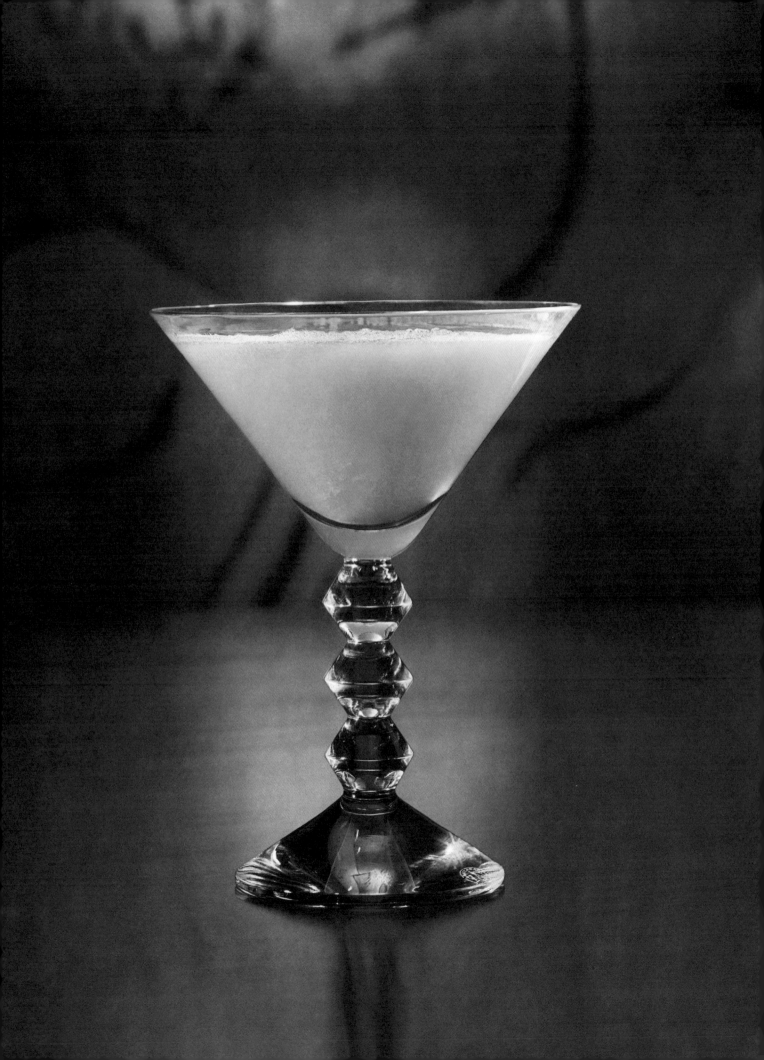

MINT JULEP

2 oz. BOURBON
1/2 oz. SIMPLE SYRUP OR
A LEVEL TEASPOON OF SUGAR
2 SPRIGS OF MINT

(use tender, young mint sprigs. They last longer and look better in the glass)

Gently bruise one sprig of mint in the bottom of a highball glass with sugar or syrup. Add half of the Bourbon and fill with crushed ice. Swirl with a bar spoon until the outside of the glass frosts. Add more crushed ice and the remaining bourbon; stir again to frost the glass.

Garnish with second mint sprig.

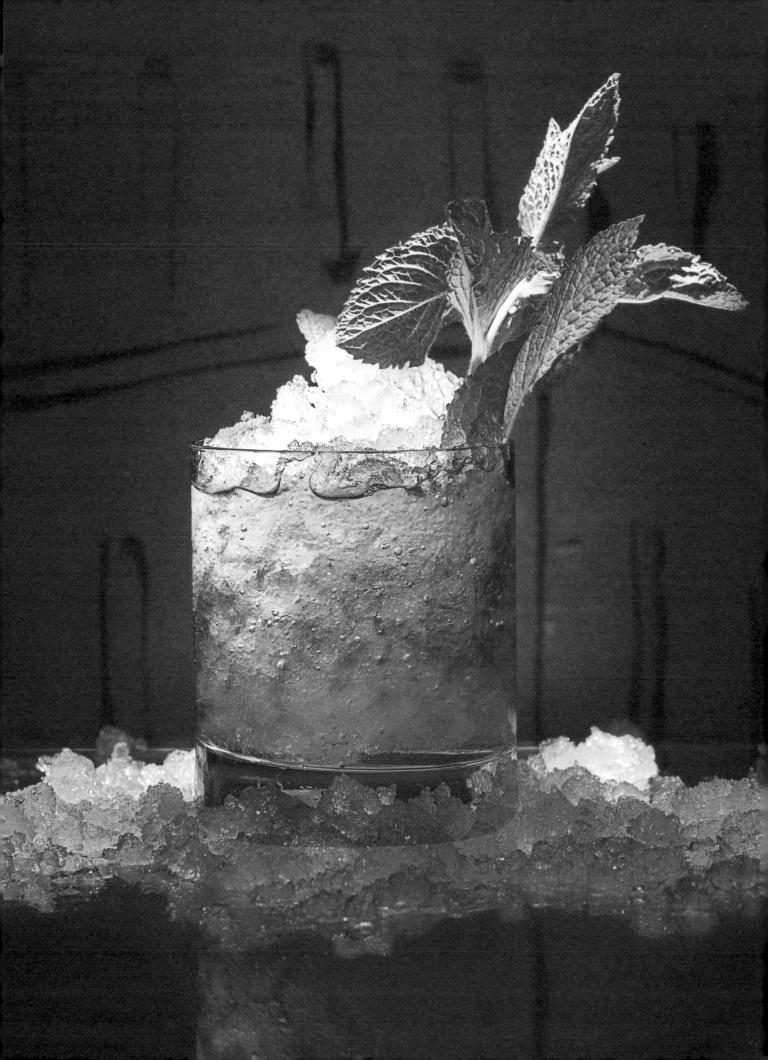

MOJITO

1 1/2 oz. white rum

3/4 oz. fresh lime juice

1 oz. simple syrup

1/4 oz. club soda

1 mint sprig and 10 mint leaves

Muddle mint leaves
and sugar until bruised
and strain over fresh ice
in a rocks glass. Add soda and
tumble roll. (use tender, young mint tops;
peppermint is best because it doesn't wilt and
retains its shape)

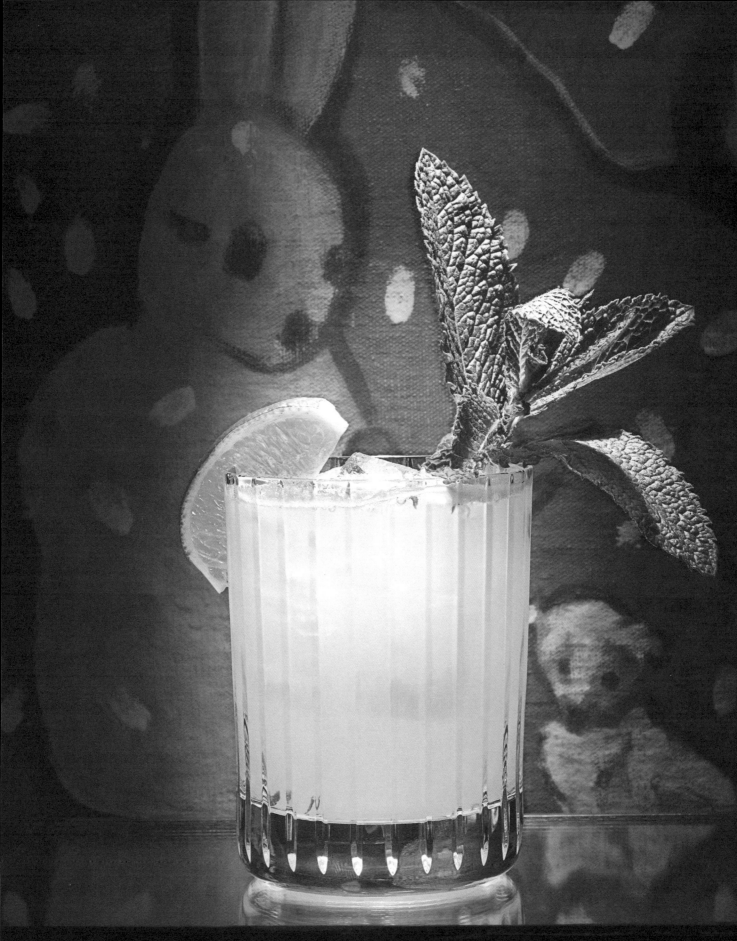

MOSCOW MULE

1 ½ oz. VODKA
GINGER BEER
3 LIME WEDGES

Combine Vodka and ginger beer in an iced glass and squeeze both lime wedges into the drink, discarding one and dropping the other in the drink. Tumble roll and strain on fresh ice into rocks glass.
Garnish with a third lime wedge.

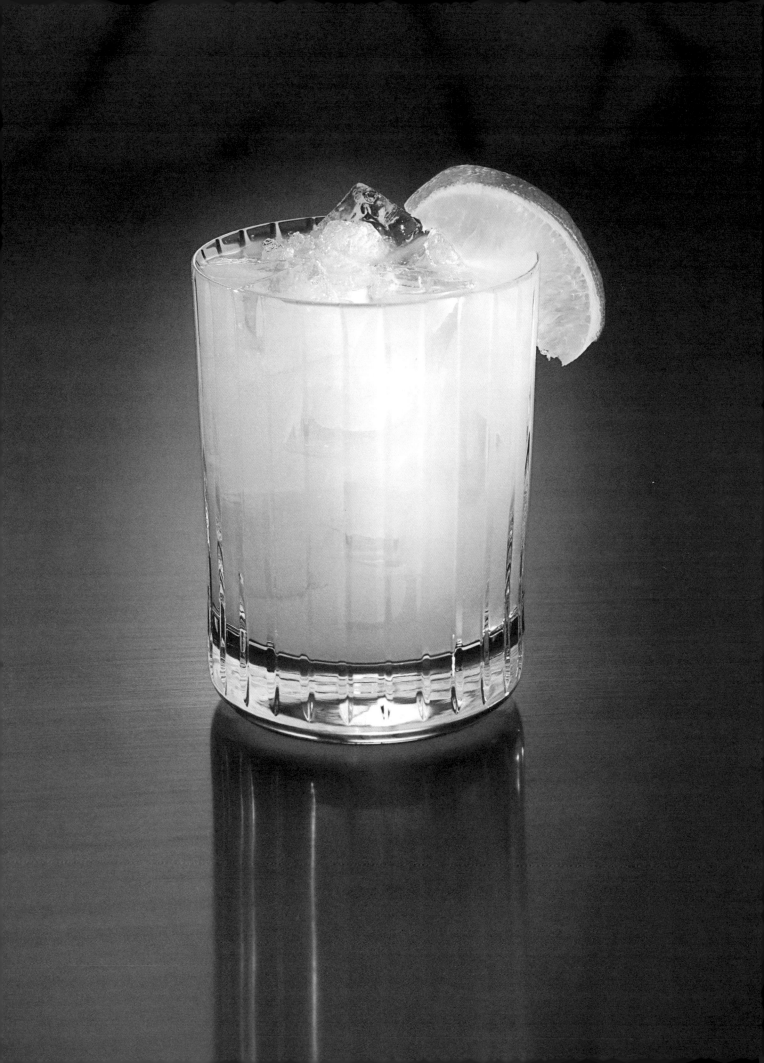

NEGRONI

1 oz. CAMPARI

1 oz. SWEET ITALIAN VERMOUTH

1 oz. GIN

Combine all ingredients in a shaker and stir. Strain into a rocks glass over fresh ice. Garnish with an orange peel.

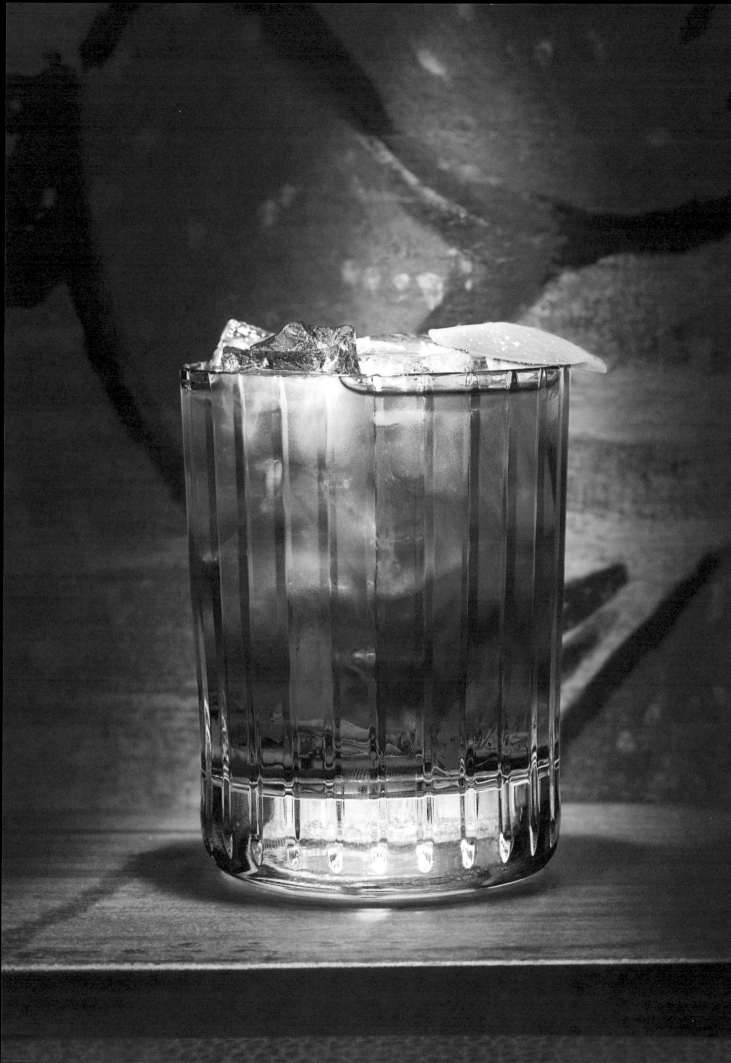

THE OLD CUBAN "Champagne Mojito"

(Created for Bemelmans Bar by Audrey Saunders)

2 oz. ZACAPA RUM

1/2 oz. FRESH LIME JUICE

1/2 oz. SIMPLE SYRUP

2 DASHES OF ANGOSTURA BITTERS

MUDDLED MINT

SPLASH OF MOËT WHITE STAR CHAMPAGNE

Mix all ingredients together (except champagne) and muddle mint until deeply bruised.
Strain out mint leaves and add ice.
Shake vigorously and strain into a martini glass.
Garnish with a fresh mint sprig.
Add a Champagne float on top and serve.

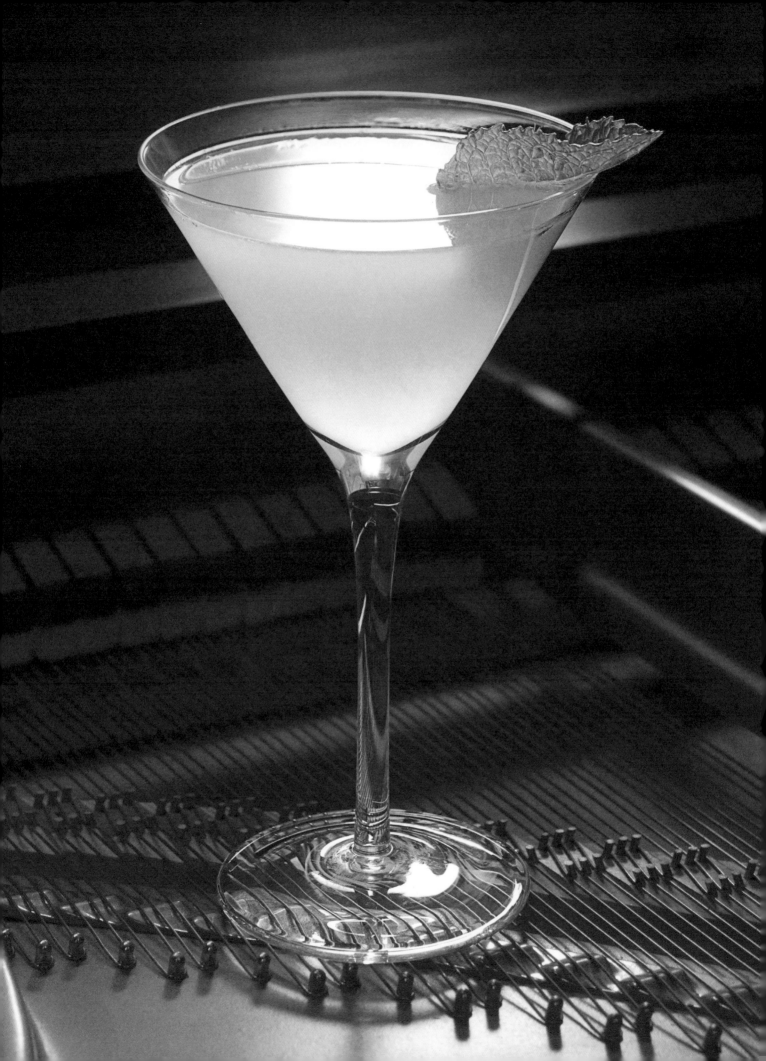

Old fashioned

2 oz. Bourbon

3 dashes Angostura Bitters

1 tsp. bar sugar

2 orange slices

2 maraschino cherries

Splash of water or soda

In the bottom of an old fashioned glass, carefully muddle the sugar, Angostura, one orange slice, one cherry, and a splash of soda. Remove the orange rind and add Bourbon, ice and soda or water.

Garnish with a fresh orange slice and a cherry.

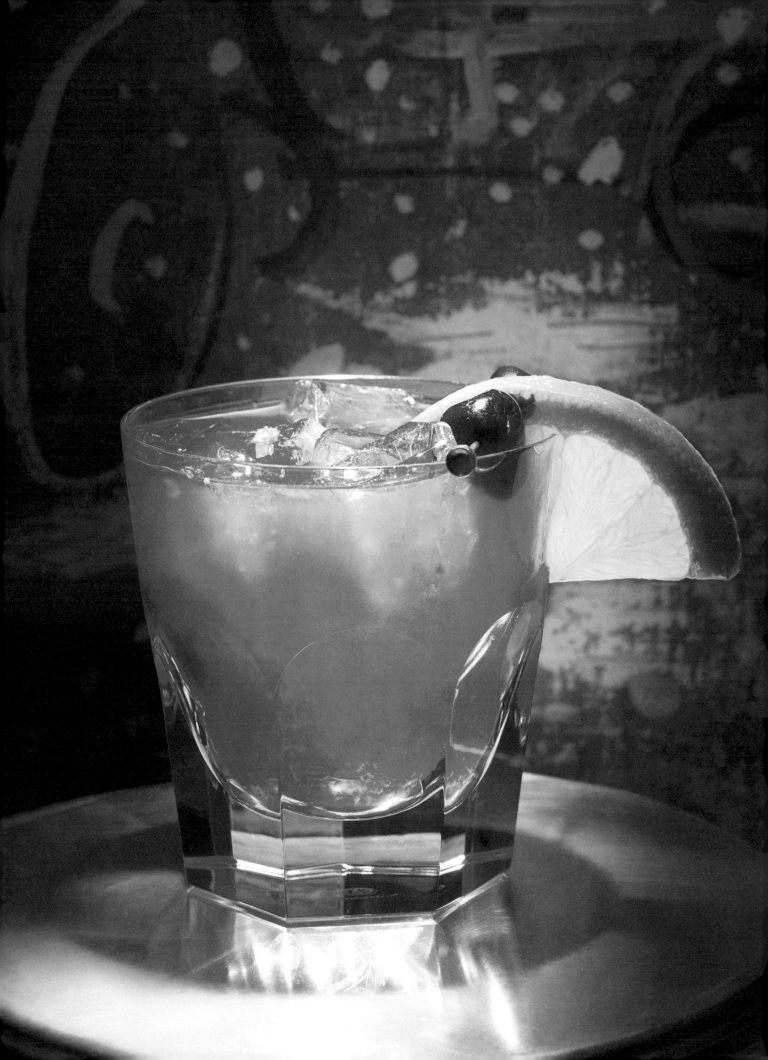

PASSION ROYALE

(Created for James McBride at The Carlyle)

¼ oz. X-Rated Passion
fruit-infused Vodka
¼ oz. fresh lime juice
½ oz. Simple syrup
2 oz. Champagne

Gently shake all the ingredients together
(except Champagne). Strain into a champagne
flute and fill with champagne.
Pull ingredients up repeatedly with bar spoon.
Garnish and serve.

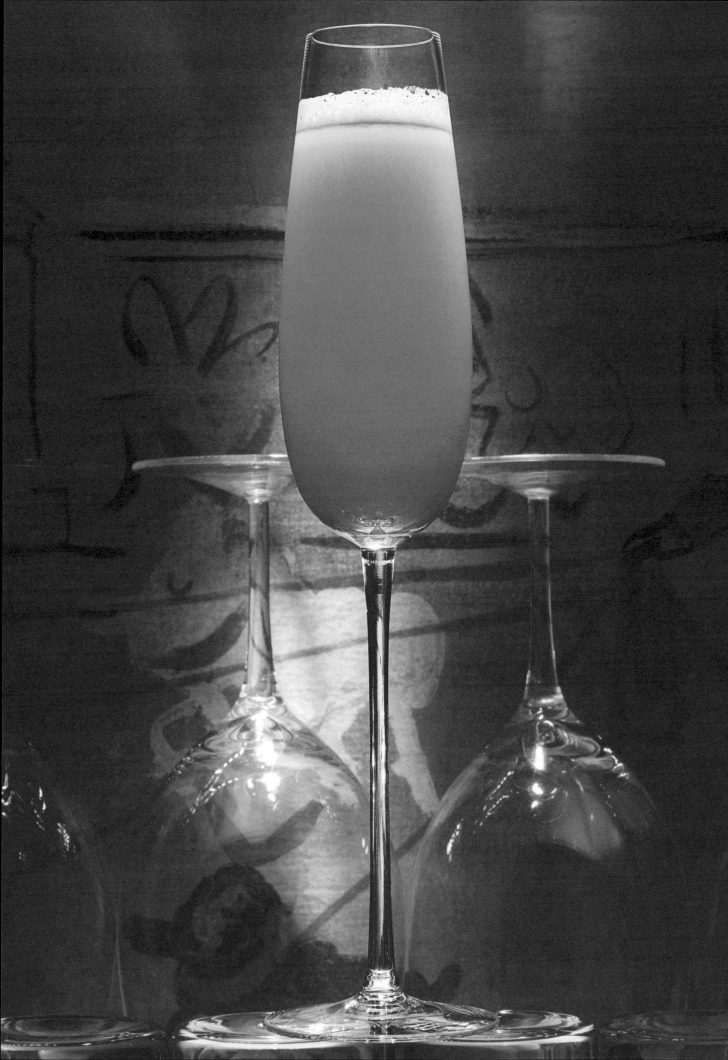

PEAR-ADISE

2 oz. GREY GOOSE la POIRE VODKA

1 oz. ANERI PROSECCO

½ oz. FRESH LIME JUICE

½ oz. SIMPLE SYRUP

2 DASHES ANGOSTURA BITTERS

Shake ingredients (except Prosecco) vigorously. Add Prosecco to shaker and taste for balance.

Strain into a martini glass garnished with fanned pear slices and serve.

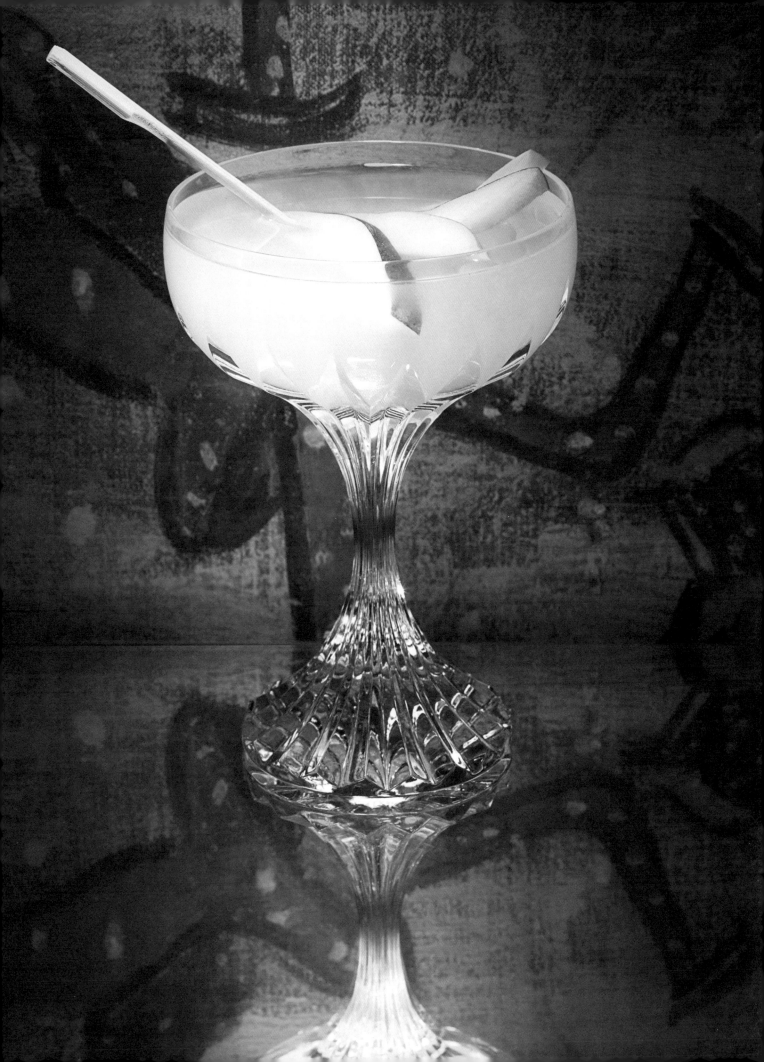

Pegu clubs cocktail

2 oz. gin

1 oz. orange curacao

1/2 oz. lime juice

1 dash Angostura Bitters

1 dash orange Bitters

Add gin and ice and shake. Strain into a chilled cocktail glass. Garnish with a lime peel.

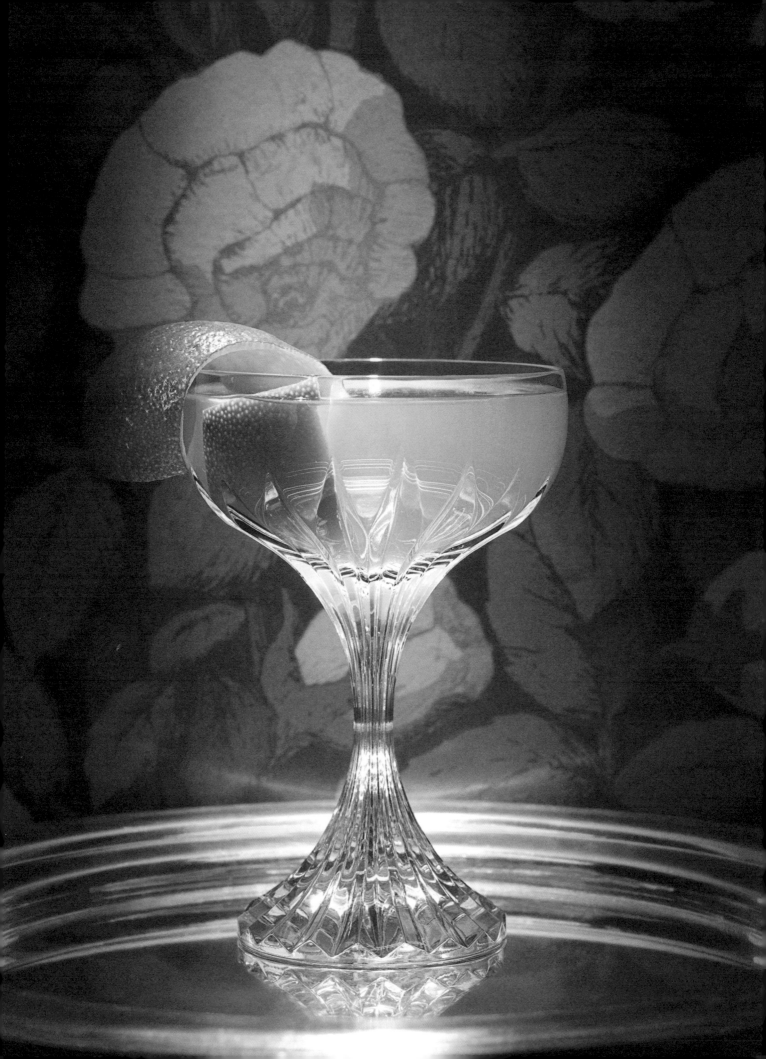

PIMMS' CUP

1 1/2 oz. PIMMS No.1

7UP (English version)

Combine ingredients
in a highball glass.

Garnish with a
wheel of cucumber and
slice of apple and/or mint.

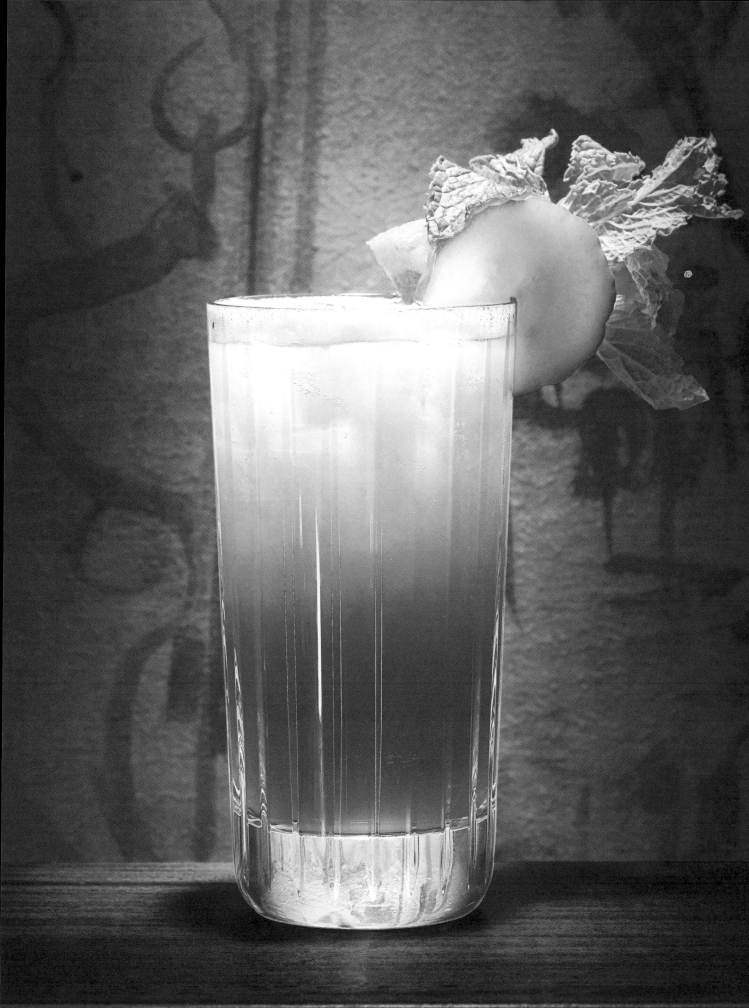

PIÑA COLADA

4 oz. FRESH PINEAPPLE JUICE

1 ½ oz. LIGHT RUM

1 CUP CRUSHED ICE

1 oz. MYERS RUM

1 PINEAPPLE WEDGE

2 oz. COCO LOPEZ
coconut cream

MARASCHINO CHERRY

1 oz. CREAM

Pour rum, coconut cream, cream and pineapple juice into a blender Add ice. Blend for 15 seconds. Pour into a tropical glass and garnish with a pineapple wedge and a maraschino cherry.

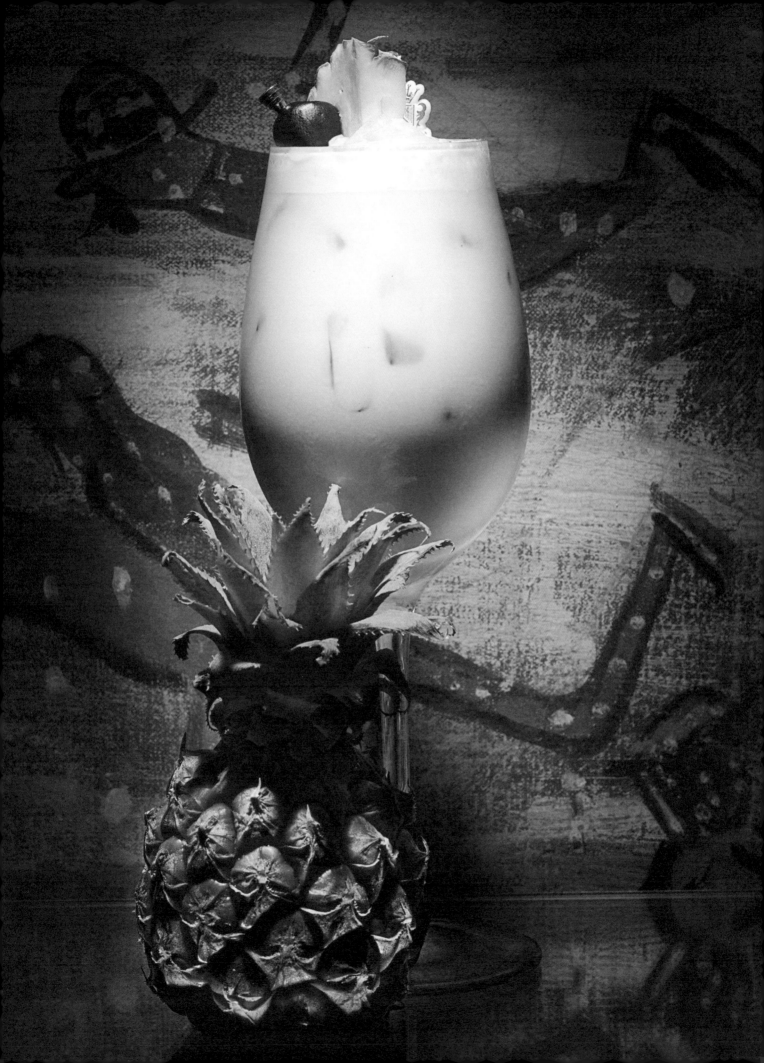

PINK LADY

1 1/2 oz. GIN

1/4 oz. GRENADINE

3/4 oz. SIMPLE SYRUP

1 oz. HEAVY CREAM

Shake all ingredients with ice and strain into a small cocktail glass.

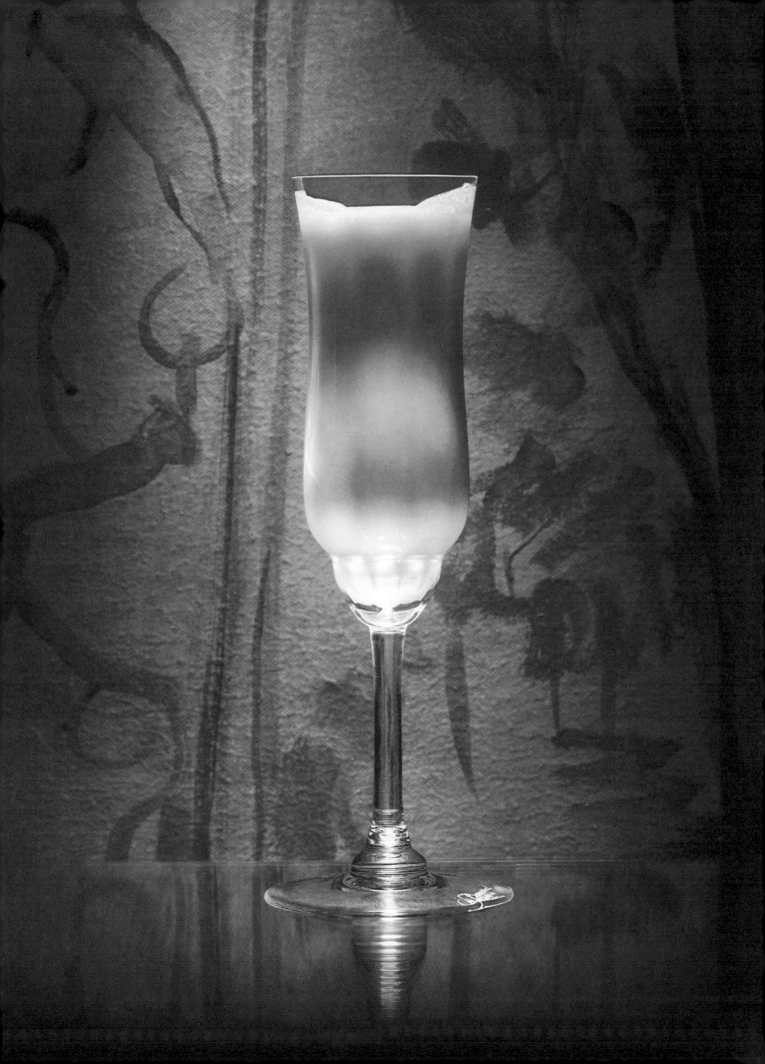

PISCO SOUR

1 1/2 oz. Pisco

3/4 oz. fresh lemon juice

1 oz. simple syrup

Several drops of Angostura Bitters

1 small egg white ◯

Shake all ingredients with ice and strain into a small cocktail glass. Garnish with several drops of Angostura Bitters on top of the foam created by the egg white.

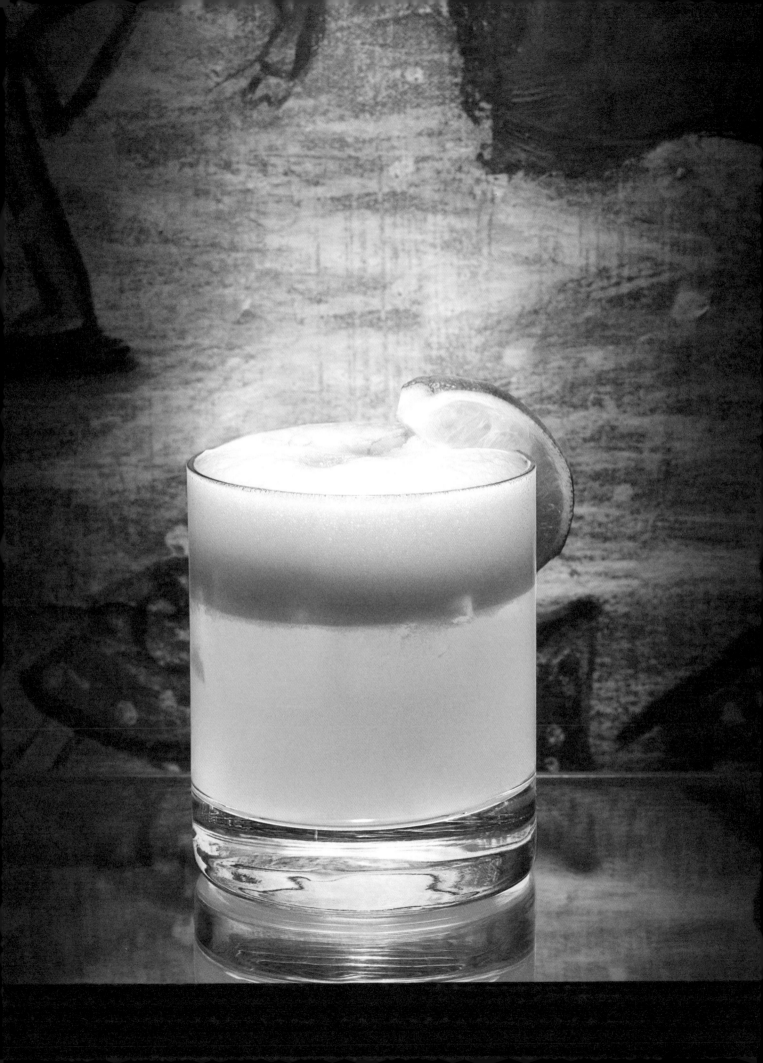

PLANTERS' PUNCH

1 oz. dark rum

1 oz. light rum

1/2 oz. orange curaçao

2 oz. fresh orange juice

2 oz. pineapple juice

1/2 oz. simple syrup

1/4 oz. fresh lime juice

Dash of grenadine

Dash of Angostura Bitters

Shake all ingredients well with ice and strain into a glass. Garnish with an orange slice and cherry. Top with soda.

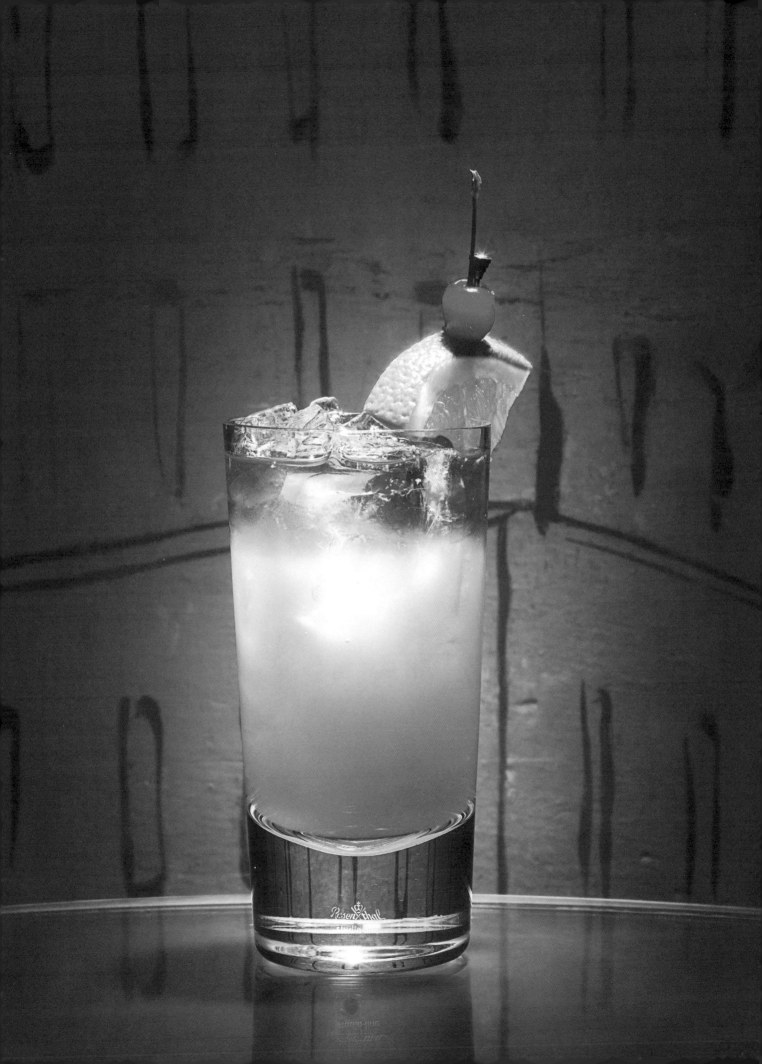

POUSSE CAFÉ

1/2 oz. grenadine 1/2 oz. dark cacao

1/2 oz. green crème de menthe

1/2 oz. white crème de cacao

1/2 oz. Apricot Brandy

Pour grenadine on the bottom, followed by dark cacao, green menthe, then white crème de cacao and finally brandy on top.

Pour carefully over the back of a spoon into a cordial glass the following ingredients in the order listed, layering one on top of the other: Grenadine, Dark Cacao, green menthe or Blue curaçao, white cacao, Apricot Brandy.

98

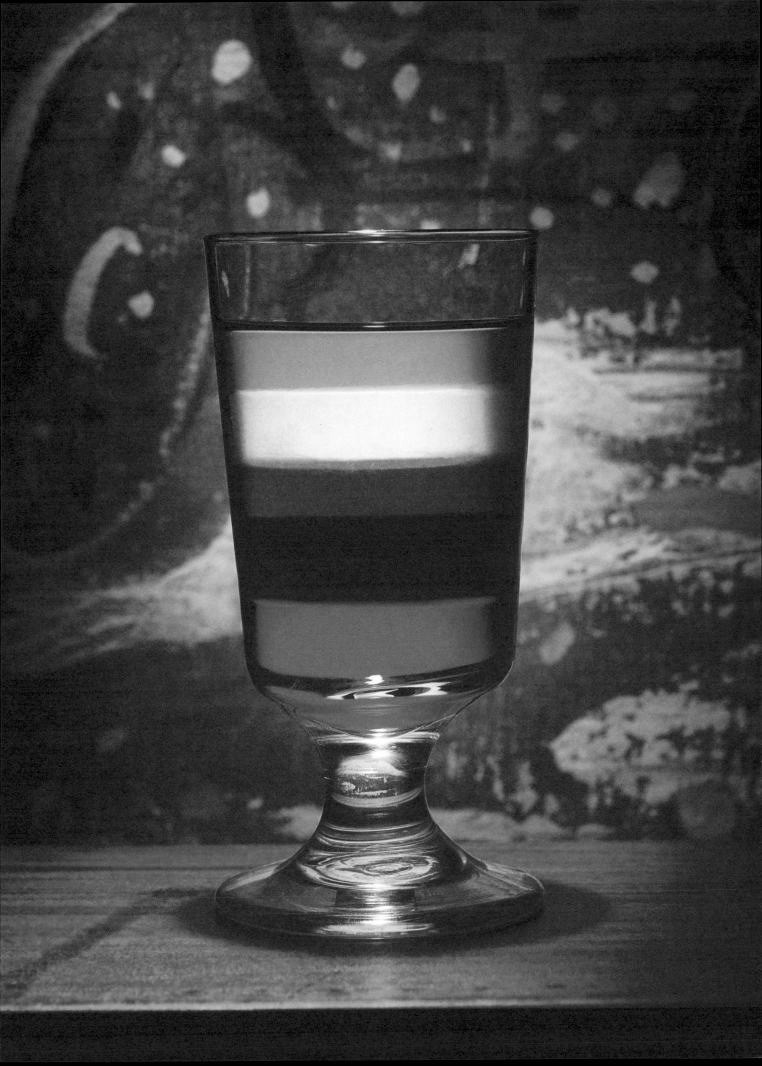

Rob Roy

2 1/2 oz. Scotch Whiskey
3/4 oz. sweet Italian vermouth
Dash Angostura Bitters

Pour all ingredients over ice in a mixing glass and stir as you would a Martini. Strain into a chilled cocktail glass and garnish with a lemon peel.

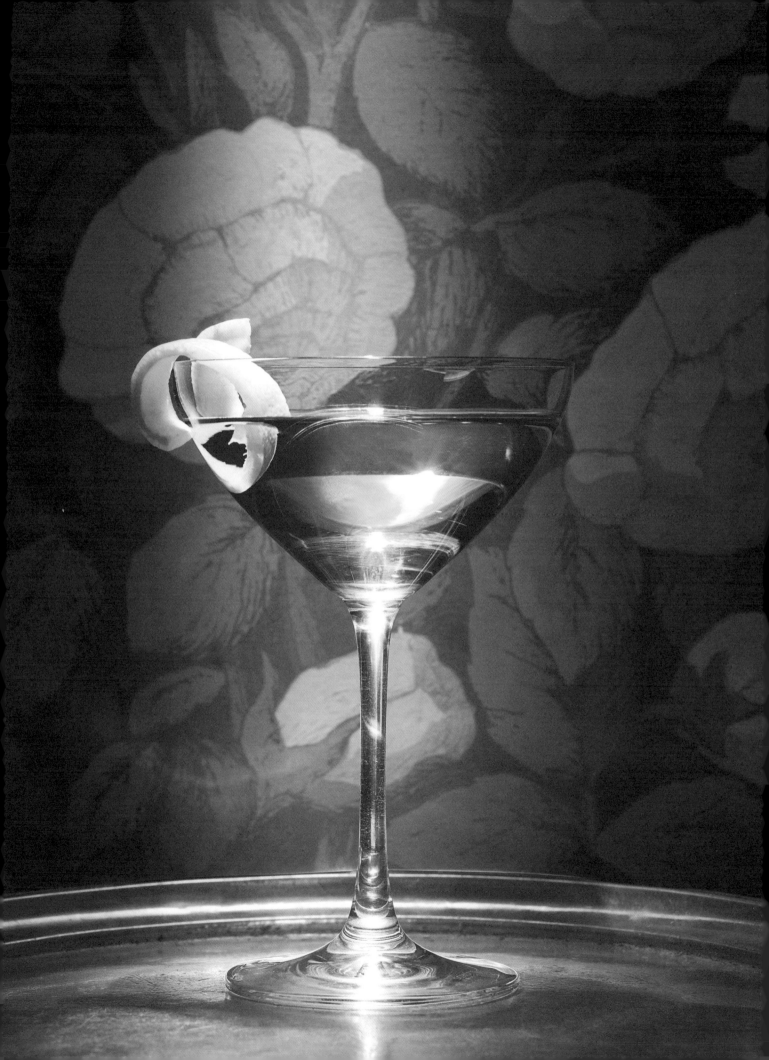

RUSTY NAIL

2 oz. Scotch

3/4 oz. DRAMBUIE

Pour scotch over ice and float the Drambuie on top- no garnish

top- no garnish
float the Drambuie on
Pour scotch over ice and

3/4 oz. DRAMBUIE
2 oz. Scotch

RUSTY NAIL

102

SALTY DOG

1 ½ oz. VODKA
4 oz. FRESH GRAPEFRUIT JUICE

frost the rim of a highball glass
with salt by rubbing a lemon or
lime wedge around the outside
rim of the glass to dampen and
dusting the rim with kosher or sea salt.
fill the glass with ice and build the drink.

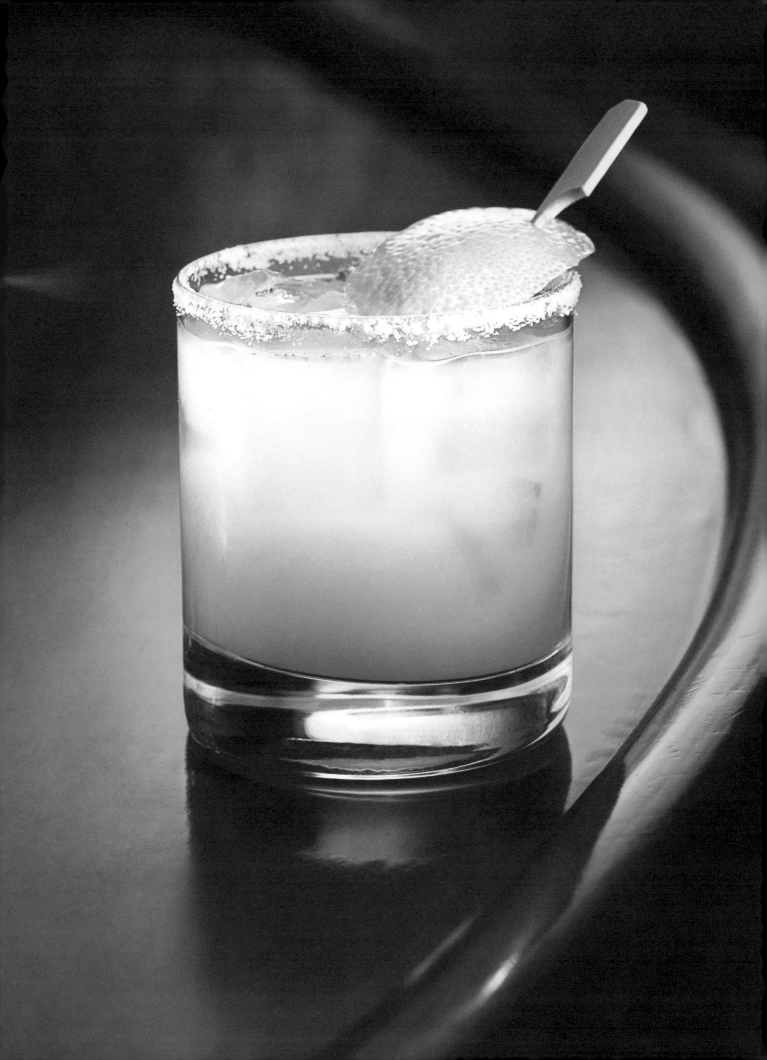

SAZERAC

2 DASHES PEYCHAUD'S BITTERS

2 oz. RYE WHISKEY

SPLASH OF HERBSAINT OR OTHER ABSINTHE SUBSTITUTE

1/2 OZ. SIMPLE SYRUP OR ONE SUGAR CUBE AND A TINY SPLASH OF WATER

Take 2 rocks glasses. Chill one while preparing the drink in the other. Splash the Herbsaint into the second glass and swirl it, then pour it out. Add the rye, syrup and/or sugar and the bitters and stir with an ice cube to chill. Strain into the chilled rocks glass and garnish with a lemon or orange peel.

SCREWDRIVER

1 ¹/₂ oz. VODKA

5 oz. ORANGE JUICE

BUILD OVER ICE in A HIGHBALL GLASS.

GARNISH WITH AN ORANGE SLICE.

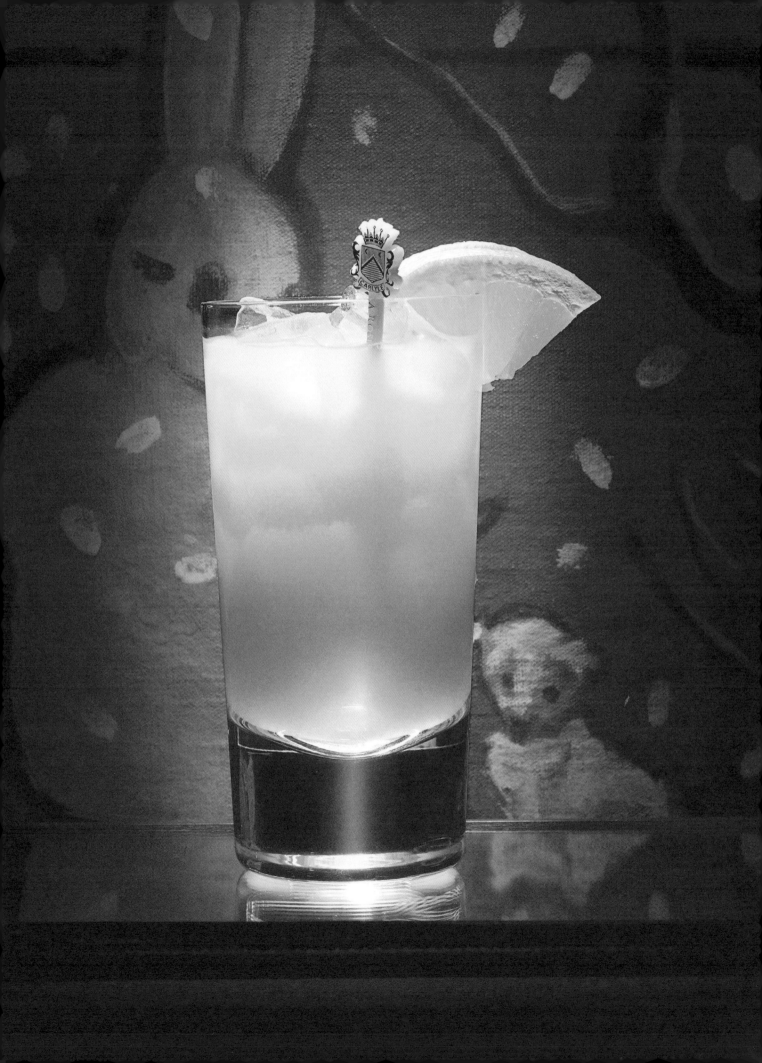

Sidecar

1 1/2 oz. Cognac

3/4 oz. Cointreau

1/2 to 3/4 oz. fresh lemon juice

Shake all ingredients with Ice and strain into an iced old fashioned glass, or preferably a cocktail glass.

Garnish with an orange peel.

Note: If served "up" strain into a small cocktail glass with a sugared rim.

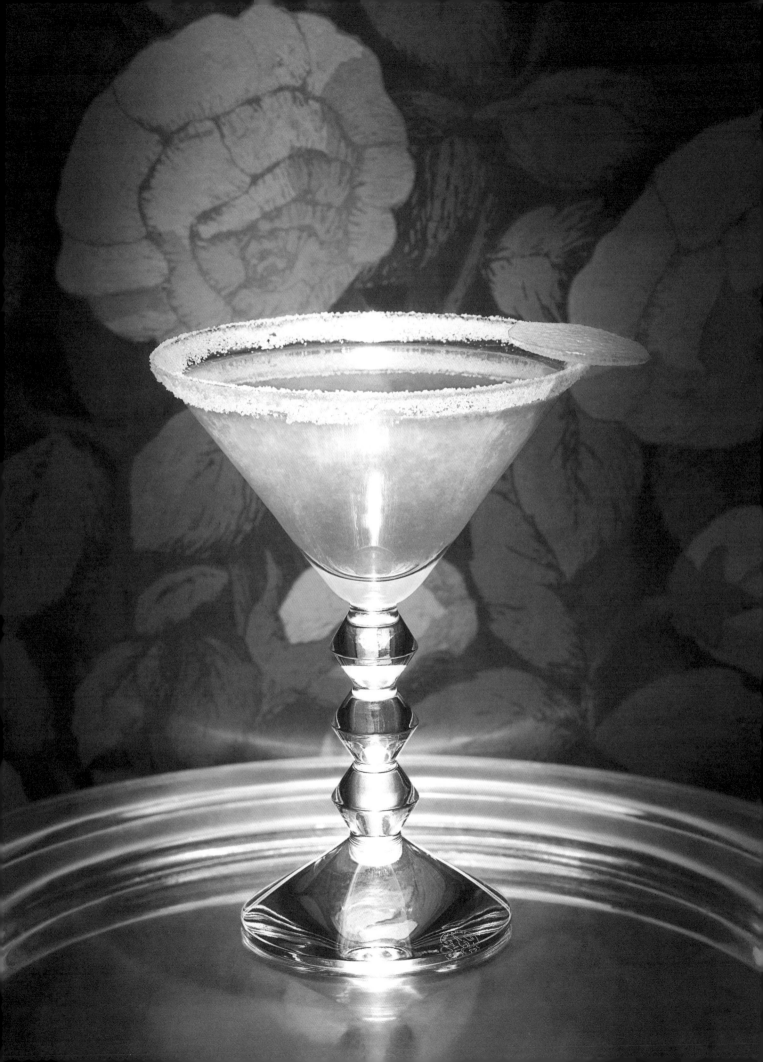

SINGAPORE SLING

1 1/2 oz. GIN

1/2 oz. CHERRY HERRING

1/4 oz. COINTREAU

1/4 oz. BENEDICTINE

2 oz. PINEAPPLE JUICE

DASH OF ANGOSTURA BITTERS

1/2 oz. FRESH LIME JUICE

SODA

SHAKE ALL INGREDIENTS WITH ICE AND STRAIN INTO A HIGHBALL GLASS. GARNISH WITH ORANGE SLICE AND CHERRY. TOP WITH SODA.

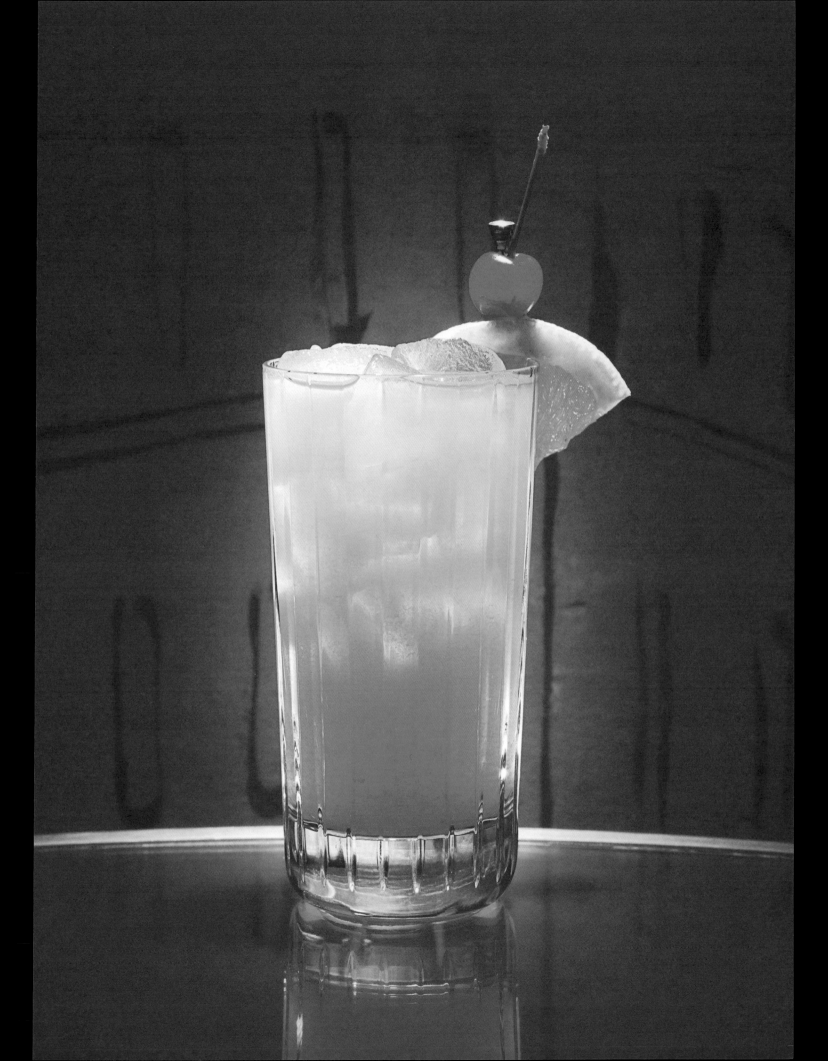

SLOE GIN FIZZ

1 oz. SLOE GIN
1 oz. GIN
3/4 oz. FRESH LEMON JUICE
1 oz. SIMPLE SYRUP
SODA OR SELTZER

Shake the first four ingredients with ice and strain into an ice-filled highball glass. Top with soda.

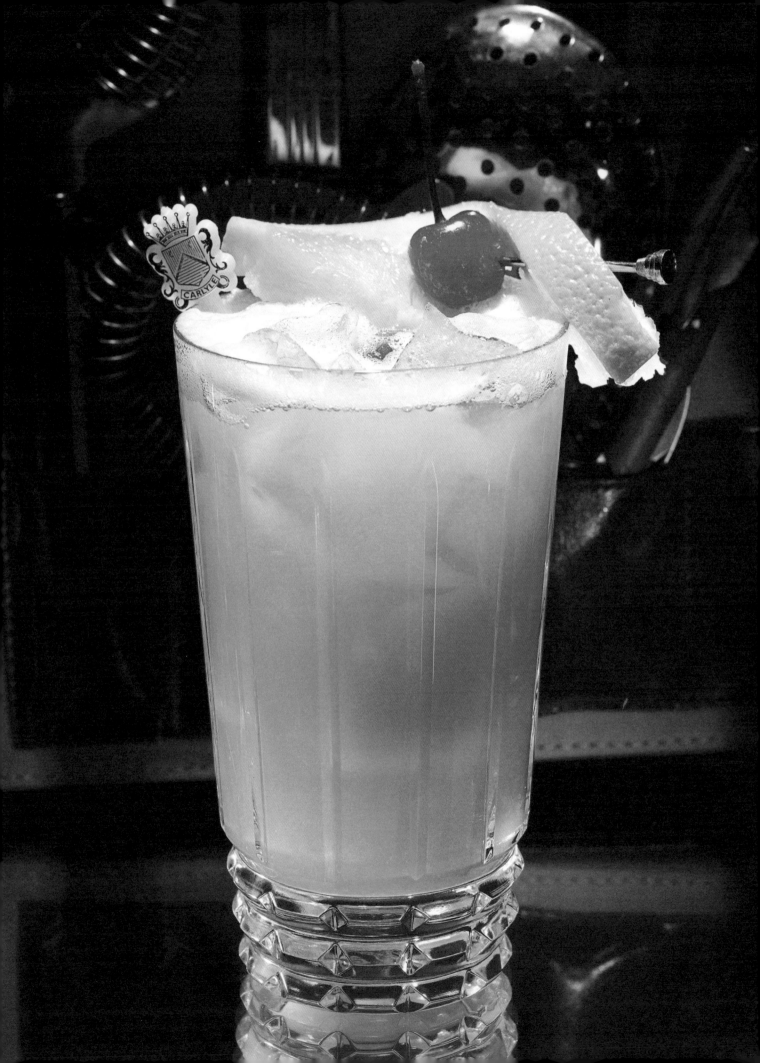

SOUTHSIDE

2 OZ. GIN

3/4 OZ. FRESH LIME JUICE

2 LIME WEDGES

1 OZ. SIMPLE SYRUP

2 SPRIGS OF MINT

SODA

muddle one of the mint sprigs with the limes, lime juice and simple syrup in the bottom of a bar glass. Add the gin and the simple syrup and shake well. Pour into a goblet over crushed ice and stir until the outside of the glass frosts. Top with soda and garnish with the other sprig of mint.

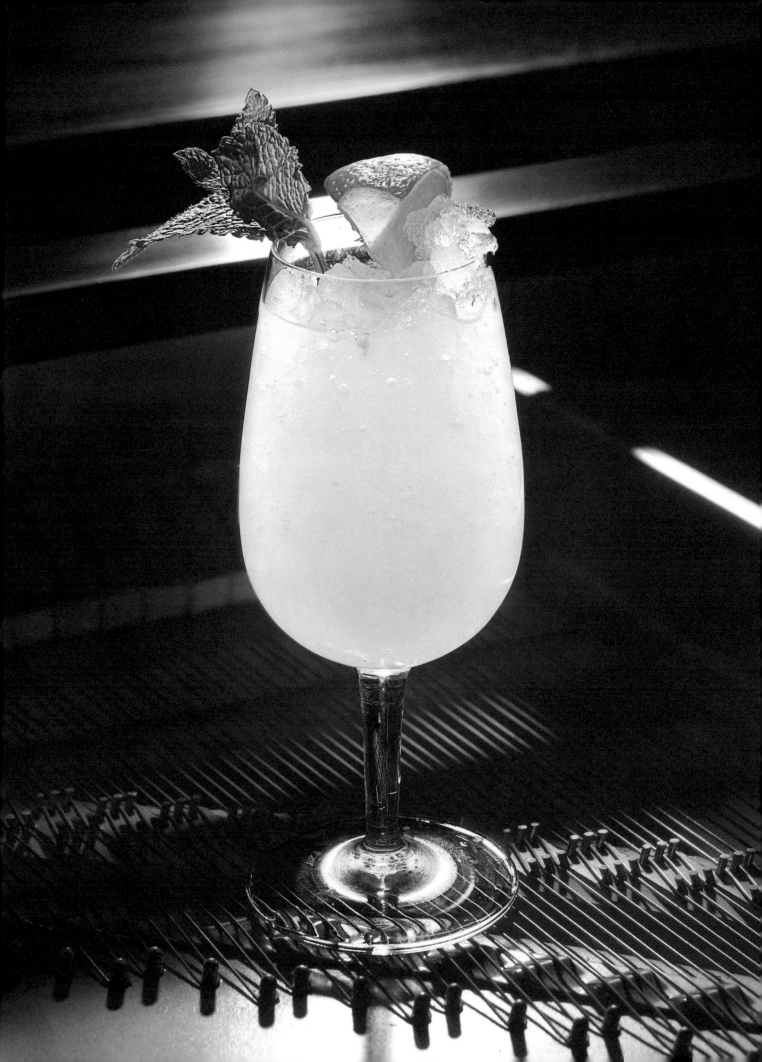

Stinger

2 oz. VS Cognac (or better)
1 oz. white crème de Menthe

Shake both ingredients with ice and strain into an old fashioned glass filled with crushed ice, or serve up in a chilled cocktail glass. Note that this is an exception to the rule that drinks with only liquors and liqueur should be stirred.

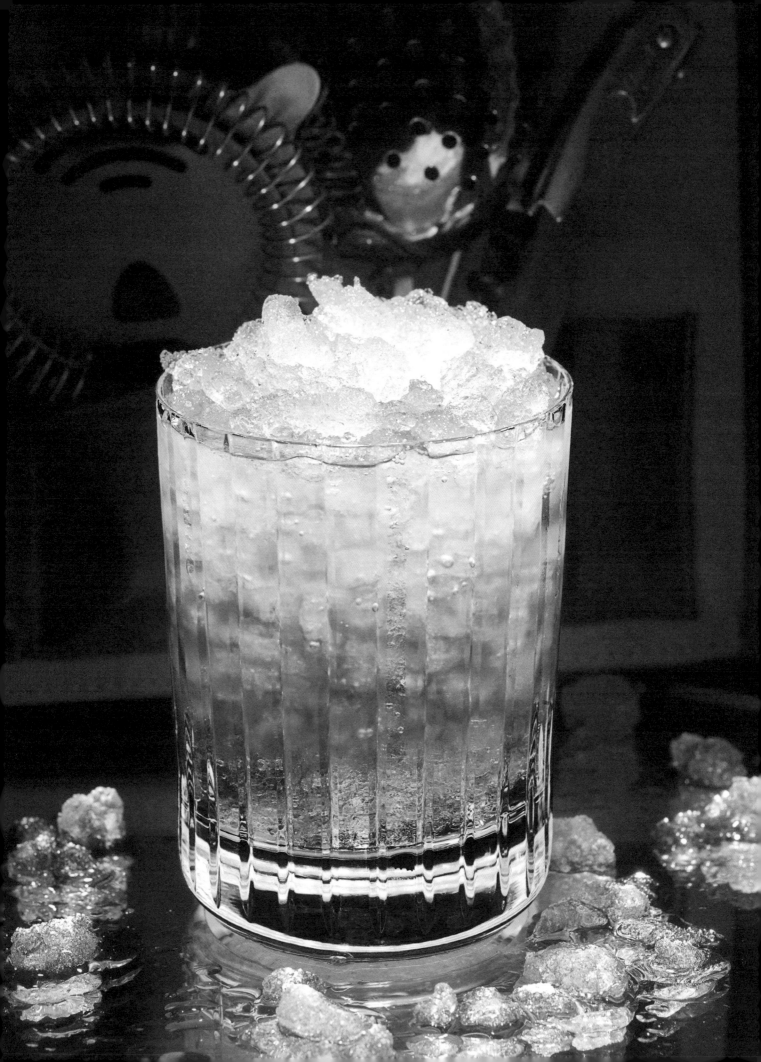

STORK CLUB COCKTAIL

1 1/2 oz. GIN

1/2 oz. TRIPLE SEC

1/4 oz. FRESH LIME JUICE

1 oz. FRESH ORANGE JUICE

1 DASH ANGOSTURA BITTERS

Shake all ingredients and strain into a Martini glass. Garnish with an orange peel.

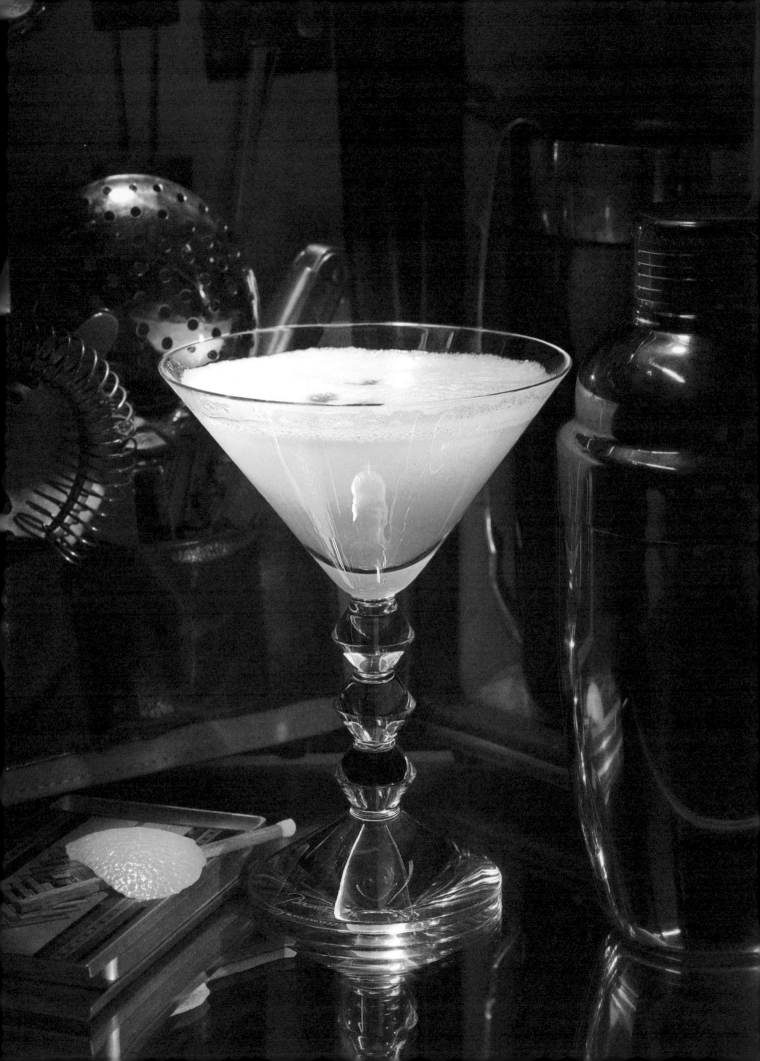

TOMMY ROWLES

This cocktail was created by Brian Van Flandern in honor of the famous Tommy Rowles, who has worked at Bemelmans Bar for 50 years, as of 2009. When asked what his favorite cocktail was he replied "a Heineken"!

1 oz. MARTELL CORDON BLEU COGNAC

1/4 oz. TEN CANE RUM

1 oz. FRESH LIME JUICE

1 1/4 oz. SIMPLE SYRUP

1 tsp. QUININE POWDER

1/2 oz. CLUB SODA

Shake the ingredients (except soda) together vigorously without ice. Strain ingredients into a highball and add club soda. Tumble roll once, garnish with a lime wedge and serve.

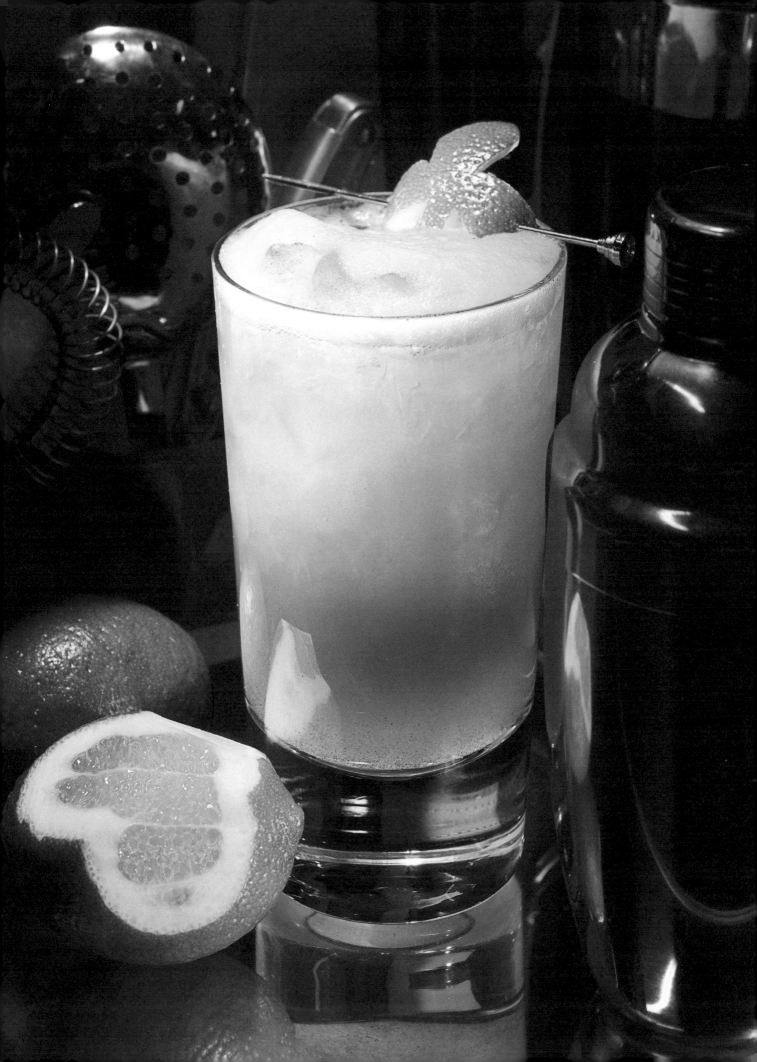

TUXEDO MARTINI

2 OZ. GIN
1 OZ. DRY VERMOUTH
2 DASHES MARASCHINO LIQUEUR
2 DASHES ANISETTE

Add all ingredients to shaker and strain into a mixing glass filled with large ice, then stir to proper dilution. Strain into a martini glass and serve.

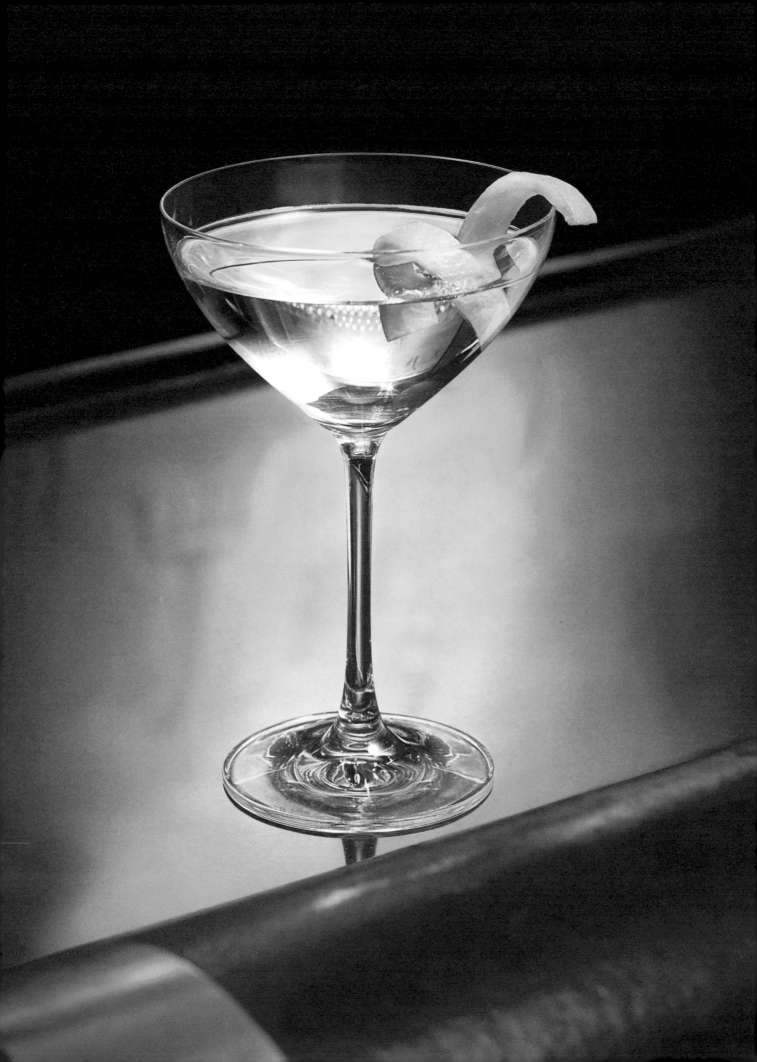

VESPER

the original James Bond Martini.

3 parts gin

1 part vodka

¼ oz. Lillet Blonde

Stir with ice and strain
into a martini glass.
Garnish with an orange peel.

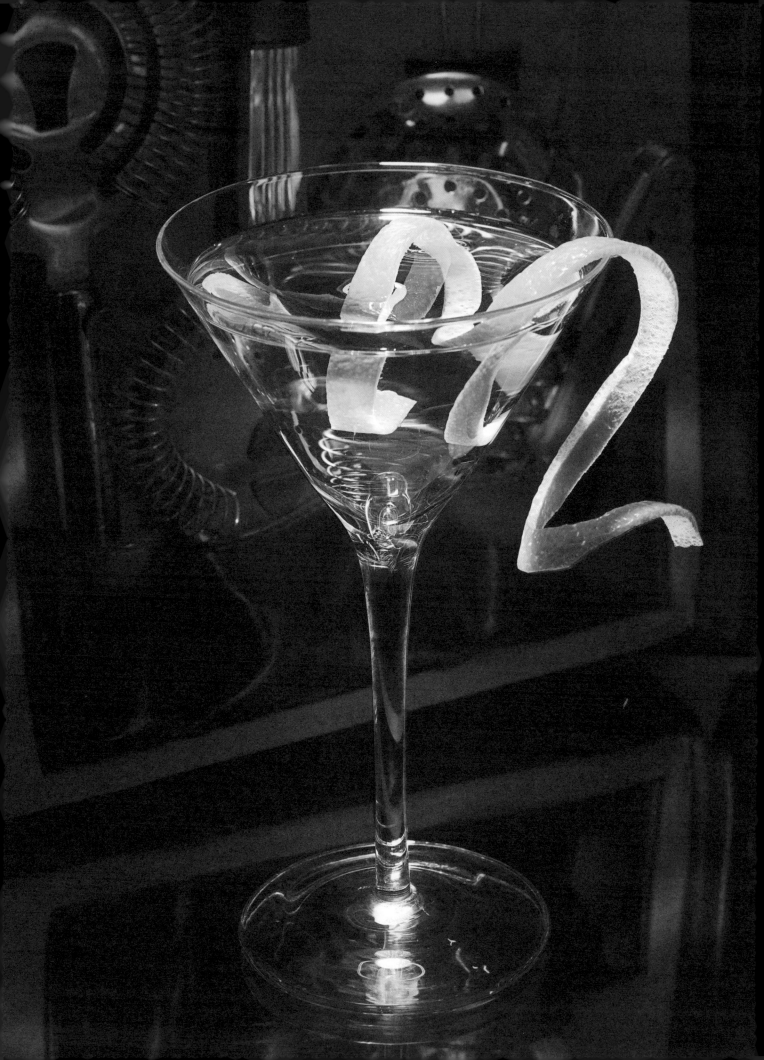

Whiskey Cobbler

4 oz. WHISKEY

1 tsp- SUGAR

2 or 3 slices of orange

Fill tumbler with ice and shake well. Strain into a highball over fresh ice.

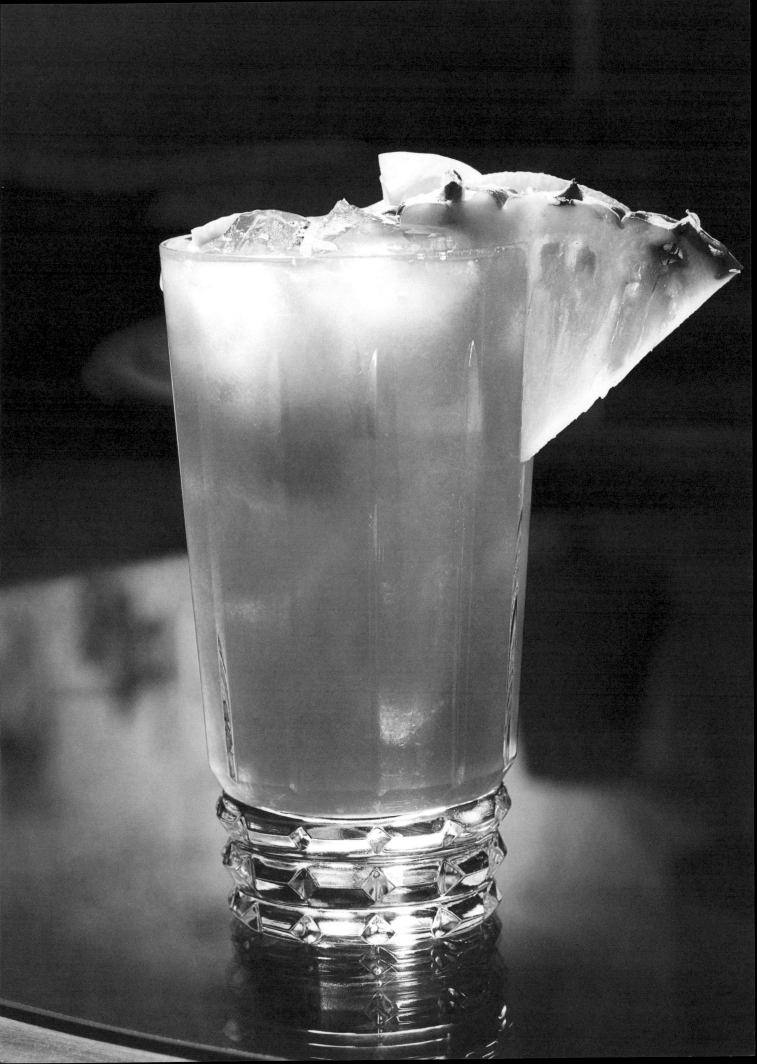

WHISKEY SMASH

(created for Bemelmans Bar by Dale DeGroff)

2oz. Bulleit Bourbon

1 oz. Lemon juice

1 oz. Simple syrup

Muddled mint

Add ingredients into a shaker with mint leaves and muddle until leaves are deeply bruised. Strain out leaves, add ice and shake vigorously. Strain into a rocks glass, garnish with a lemon wedge and mint sprig and serve.

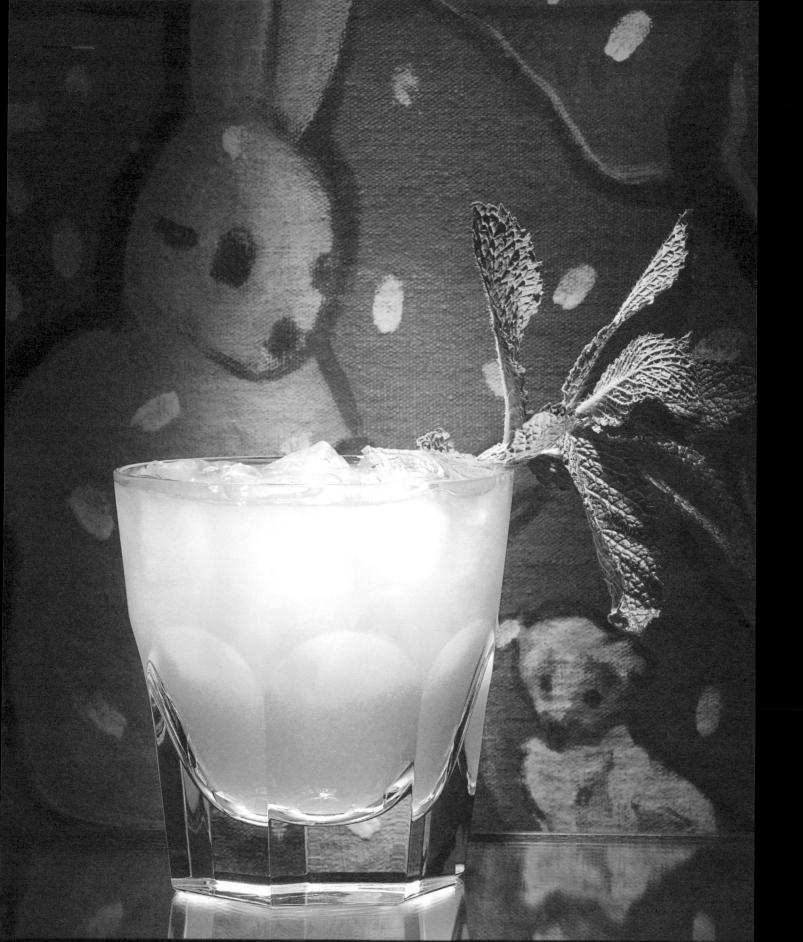

WHISKEY SOUR

2 oz. Bourbon or
rye whiskey
1 oz. simple syrup
3/4 oz. fresh lemon juice

Shake all ingredients
with ice and strain into
an old-fashioned glass.
Garnish with an orange
slice and a cherry.

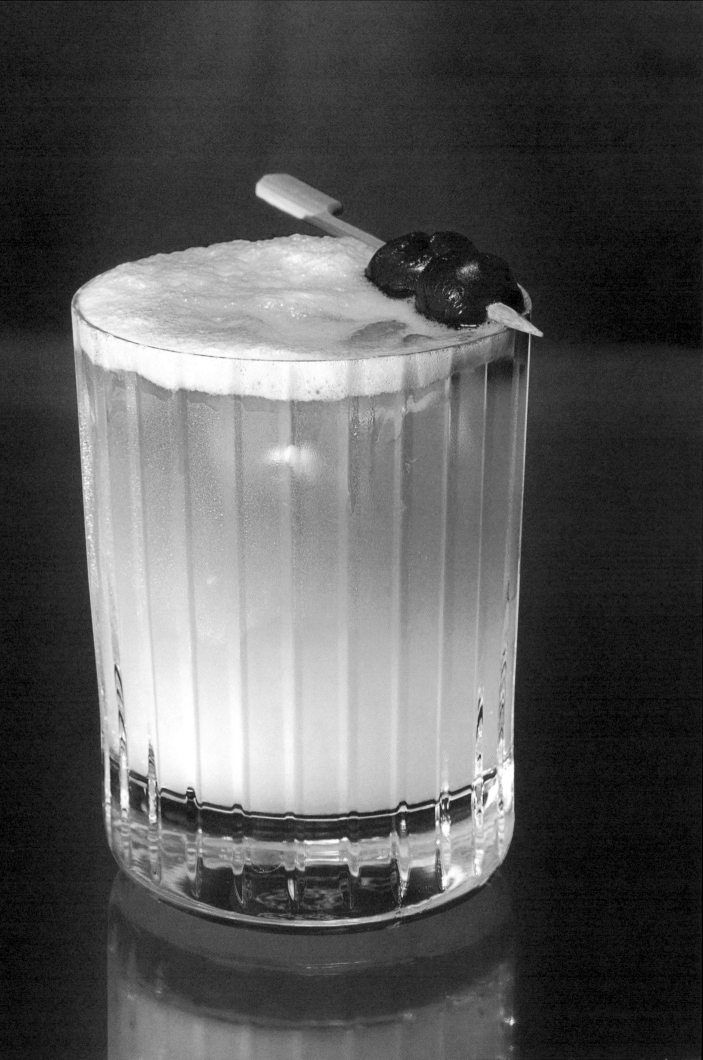

White lady

1 ½ oz. GIN

3/4 oz. fresh lemon juice

1 oz. Cointreau

Shake all ingredients with ice and strain into a cocktail glass. Garnish with an orange peel.

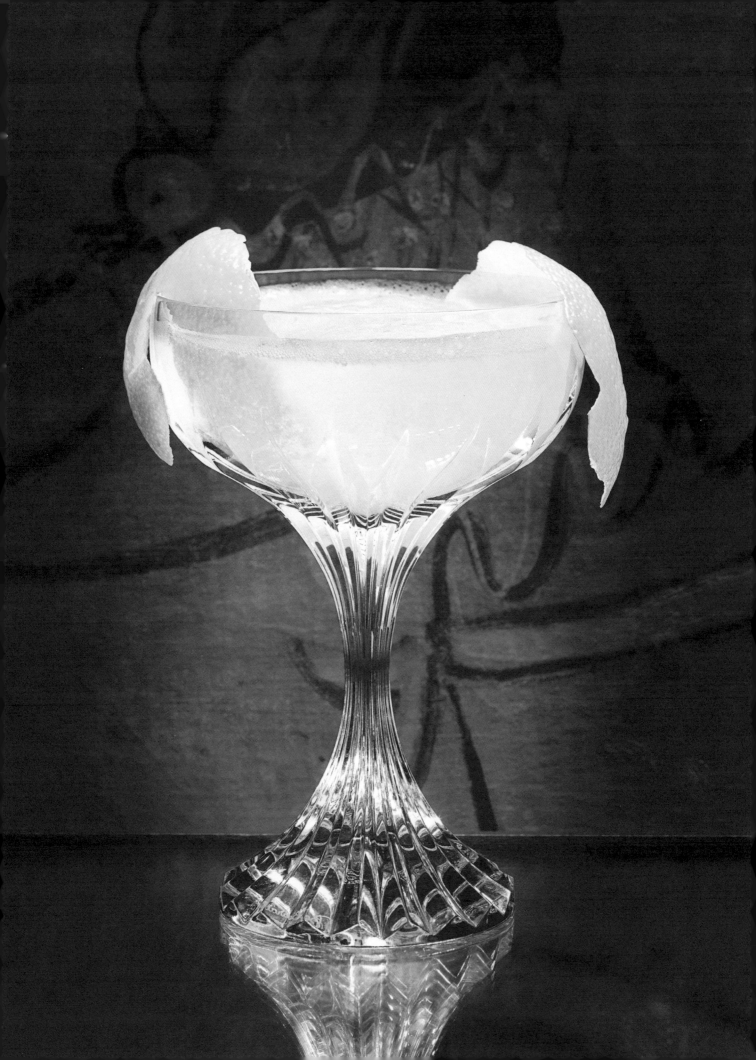

WHITE RUSSIAN

1 oz. VODKA

1 oz. KAHLUA

1 oz. HEAVY CREAM

COMBINE IN A MIXING GLASS AND SHAKE.

SERVE IN ICED ROCKS GLASS.